Masterpieces
of the J. Paul Getty Museum

EUROPEAN SCULPTURE

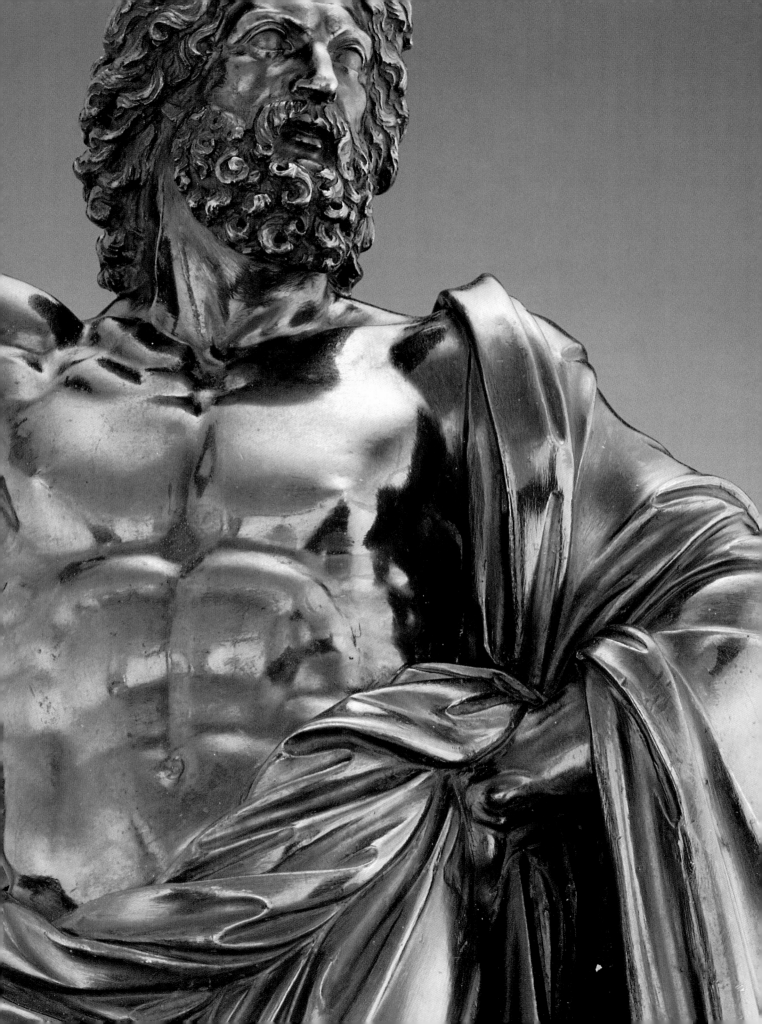

Masterpieces of the J. Paul Getty Museum

EUROPEAN SCULPTURE

THAMES AND HUDSON

Frontispiece:

MICHEL ANGUIER

Jupiter [detail]

probably cast toward the end
of the seventeenth century
from a model of 1652
94.SB.21 (See no. 21)

Page 6:

JOHN DEARE

*Venus Reclining on a Sea Monster with
Cupid and a Putto* [detail], 1785–1787
98.SA.4 (See no. 38)

Page 8:

CHRISTOPH DANIEL SCHENCK

The Penitent Saint Peter [detail], 1685
96.SD.4.2 (See no. 24)

Page 12:

JEAN-JACQUES CAFFIERI

Bust of Alexis-Jean-Eustache Taitbout
[detail], 1762
96.SC.344 (See no. 33)

Page 13:

FRANÇOIS GIRARDON

Pluto Abducting Proserpine [detail],
cast circa 1693–1710
88.SB.73 (See no. 26)

Texts prepared by Peter Fusco
(abbreviated in text as PF),
Peggy Anne Fogelman (PAF),
and Marietta Cambereri (MC)

Designed and produced
by Thames and Hudson
and copublished with the
J. Paul Getty Museum

© 1998 The J. Paul Getty Museum
1200 Getty Center Drive
Suite 1000
Los Angeles, California 90049-1687

British Library Cataloguing-in-Publication Data

A catalogue record for this book is available from the British Library

ISBN 0-500-17023-1

Colour reproductions by Articolor, Verona, Italy
Printed and bound in Singapore by C.S. Graphics

CONTENTS

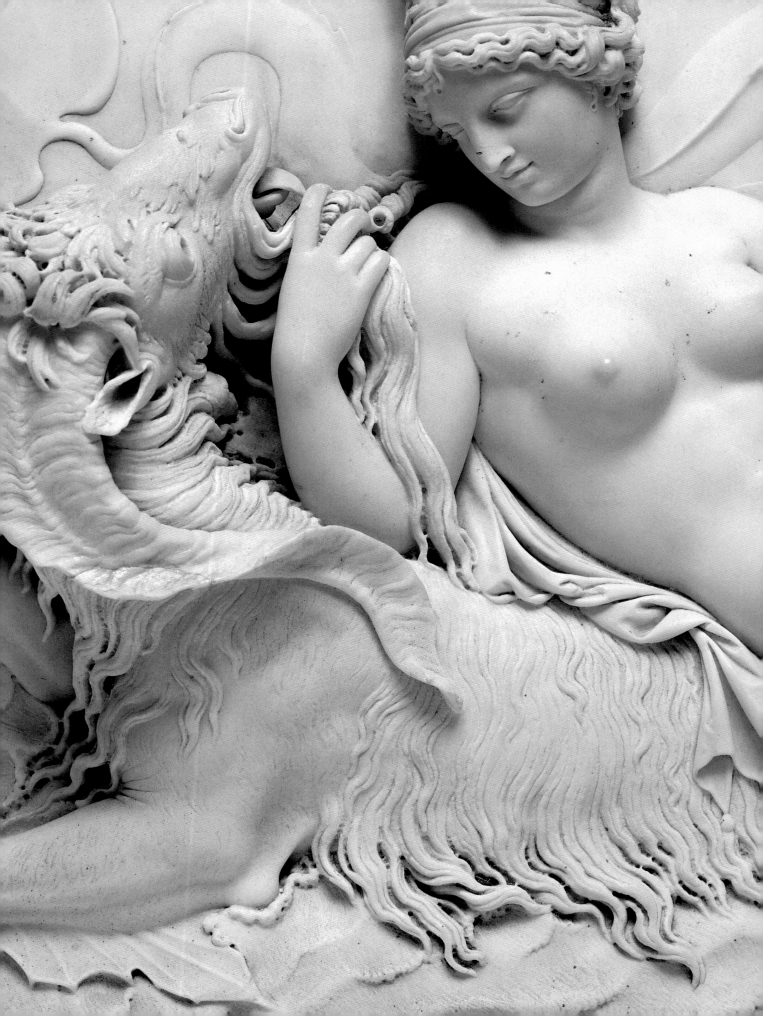

FOREWORD

The collection of European sculpture represented here, begun in 1984, has just been installed in galleries built for it in the new J. Paul Getty Museum. Seeing the collection in this new context is a revelation to visitors; for us, it is a reminder of how much more has been accomplished in just fourteen years than we had imagined possible. The curators have assembled a group of sculptures ranging in date from the late fifteenth to the early twentieth century, with works in various media by many of the greatest European sculptors: Laurana, Antico, Cellini, Giambologna, Bernini, Clodion, Canova, and Carpeaux, to list only a few. The collection is especially strong in late Renaissance and Baroque bronzes, with masterpieces by Schardt, De Vries, Tacca, and Soldani.

The building of the collection has been the work of Peter Fusco, the Museum's first curator of sculpture, and two associate curators, Peggy Fogelman and Catherine Hess. This book is the sixth in a series intended to introduce to the general public the high points of the Museum's seven curatorial departments. I am grateful to Peter Fusco for his thoughtful introduction and to Peggy Fogelman and Marietta Cambareri, as well as to Peter Fusco, for writing entries on individual pieces.

Readers seeking more information about the Getty's European sculpture should consult two books published by the Museum in 1997: *Looking at European Sculpture: A Guide to Technical Terms* by Jane Bassett and Peggy Fogelman, and the *Summary Catalogue of European Sculpture in the J. Paul Getty Museum* by Peter Fusco. A two-volume specialized catalogue of the sculpture collection will appear in the next few years.

DEBORAH GRIBBON
Associate Director and Chief Curator

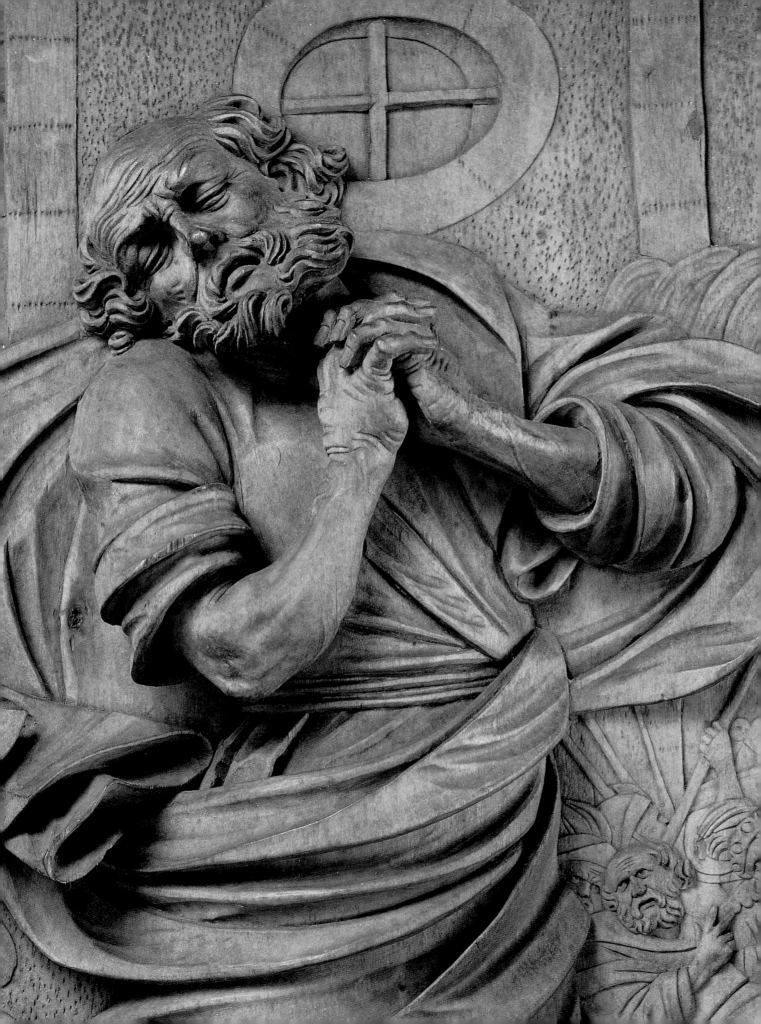

INTRODUCTION

I forget who first jokingly defined sculpture as something you bump into when you step back to look at a painting. In any case, like most witticisms, this one contains a germ of truth: both the general public and scholars pay more attention to painting than to sculpture. There are undoubtedly many reasons for this. We are a society geared to experiencing things on a flat plane rather than in three dimensions. Not only do we learn from the pages and photographs in books, magazines, and scholarly journals, but television and now the computer play ever greater roles in our lives. As far as the teaching of art history is concerned, we depend primarily upon the projection of slides onto a flat screen. In colleges and universities, the overwhelming majority of art-history courses give greater emphasis to painting than to sculpture—except, of course, when dealing with a period or culture such as Classical Greece, from which little other than three-dimensional objects has survived. It is not surprising, therefore, that paintings, prints, and drawings tend to be more avidly collected than sculpture and that, in recent decades, there has been an explosion of interest in photographs.

For anyone who doubts the relative lack of interest in sculpture, it is only necessary to look at the art market, where the prices of sculpture purchases fall far below those of painting, even though great sculptures are rarer on the market. From the point of view of the private collector, it can be argued that the three-dimensional object is a more demanding possession. Paintings, prints, photographs, or illuminated manuscripts are usually less expensive to pack and transport safely and are easier to display. It is clearly more difficult to hang a sculpture than a painting over a sofa or bed, and if the object is any larger than a bibelot, it becomes a presence that invades one's space and may require a niche or a pedestal for support.

This preference for painting over sculpture is nothing new. In 1846, the young Charles Baudelaire, a fervent admirer of Eugène Delacroix, wrote a notorious essay entitled "Why Sculpture Is Boring" ("Pourquoi la sculpture est ennuyeuse"). Since the Renaissance, in fact, theoretical debates over the relative merits of the two arts (called *paragoni*) have most often come out in favor of painting. Because sculpture usually requires more manual labor, the sculptor has had greater difficulty in throwing off his medieval "craftsman" associations, while the painter more easily, and earlier in history, achieved the social rank of "artist." Recently, in the *Times Literary Supplement*, a reviewer wrote that "it is considerably more difficult to translate three dimensions onto a two-dimensional surface than it is to represent an object directly in three dimensions; and neither Greek, Roman, nor Egyptian cultures ever completely achieved it, although all of them were highly skilled at representing three-dimensional forms sculpturally." This is not the occasion to debate this issue again, but the quotation illustrates the

lingering suspicion that sculpture is less elevated, worthy, and intellectually sophisticated than painting.

Since the establishment of art history as an academic discipline in the nineteenth century, our knowledge of the history of European painting has advanced farther and faster than is the case with sculpture. This may be because of some of the factors mentioned above; but, in certain respects, the study of sculpture may be inherently more difficult. For example, a photograph or slide used for study provides a better idea of a painting or drawing than it does of a sculpture: the single flat image can capture only one of the infinite possible views of a sculpture in the round. Also, the study of sculpture requires an understanding of numerous techniques, including the modeling of clay and wax; the carving of wood, ivory, and marble; the casting of terracotta and plaster; the several methods of casting bronze; and the processes of patination, glazing, and polychroming. Moreover, with certain types of sculpture, such as Renaissance bronze statuettes, a sophisticated level of connoisseurship cannot be attained solely by intense looking but requires handling the objects—a kind of access that, for works in a museum, is generally very restricted.

Even with these difficulties, sculpture collections have continued to be created, though it is difficult to explain the reasons and motives behind the formation of any one collection. Ranging from the lofty aim of creating a beautiful ensemble to a crass interest in financial investment, there is a gamut of human needs and impulses that in some way are satisfied by bringing together a group of art works. Since the earliest collections of precious objects were first formed, primarily out of religious, political, and propagandistic motives, in temples, tombs, and the palaces of the powerful, collecting art has generally been viewed as a worthy pursuit and an important element in the development of culture. The prestige associated with it has, today, led to a situation in which social status is frequently a major impetus behind the formation of a collection and the kinds of works selected. In such an ambience, the object satisfies criteria that the collector can securely identify as being socially acceptable; there is a gravitation toward works that can be clearly identified and categorized, with inordinate importance given to those that are signed and dated. The same cultural climate encourages a tendency to collect in very limited, specialized areas, so that the greatest possible control can be brought to bear on the selection of a new acquisition. Given the current predominant cultural values, it is understandable why the areas of sculpture collecting most popular today are nineteenth-century *animalier* bronzes and the works of Edgar Degas and Auguste Rodin: unlike much earlier European sculpture, these are almost invariably signed by the artist. (It may be worth noting the irony that the

entrances to an unusually large percentage of America's greatest museums are graced with a Rodin bronze—like a corporate logo intended to convey an immediate message: "This is an art museum"—while almost all of these same institutions devote a greater amount of gallery space to displaying painting than sculpture.)

It should be evident to the reader of the present volume that the J. Paul Getty Museum's sculpture collection is far from comprehensive or coherent in any rigorous way. It is the most recently created, the smallest, but the most diversified of the Museum's collections. It ranges in time from the 1470s to 1911. It includes a wide variety of media: plaster, terracotta, wood, polychromed wood, ivory, alabaster, marble, bronze, silver, and gold. Typologically, it is also varied and includes portrait busts, ideal heads, single figures, groups, reliefs, and several works created to perform practical functions. Some objects are religious, others secular or decorative. There are represented religious, mythological, allegorical, and genre subjects. If there is one consistent thread that holds the collection together, it is, I hope, a high level of aesthetic quality, historical interest, and rarity. Whether or not this is the case is for the reader to decide. But it is undeniable that the decision by the Director and Trustees of the J. Paul Getty Museum to create a curatorial department focused on European sculpture has helped make the Museum special. I also hope that this modest book, containing selected highlights of our collection, will inspire interest in a relatively neglected field.

PETER FUSCO
Curator

NOTE TO THE READER

Entries are arranged in chronological order.

Dimensions are given in centimeters, followed by inches in parentheses. A single dimension indicates height; a second, width; a third, depth.

In inscriptions, a slash mark indicates the beginning of a new line.

In the accession number given for each object, the first two digits indicate the year in which the work was acquired by the Museum.

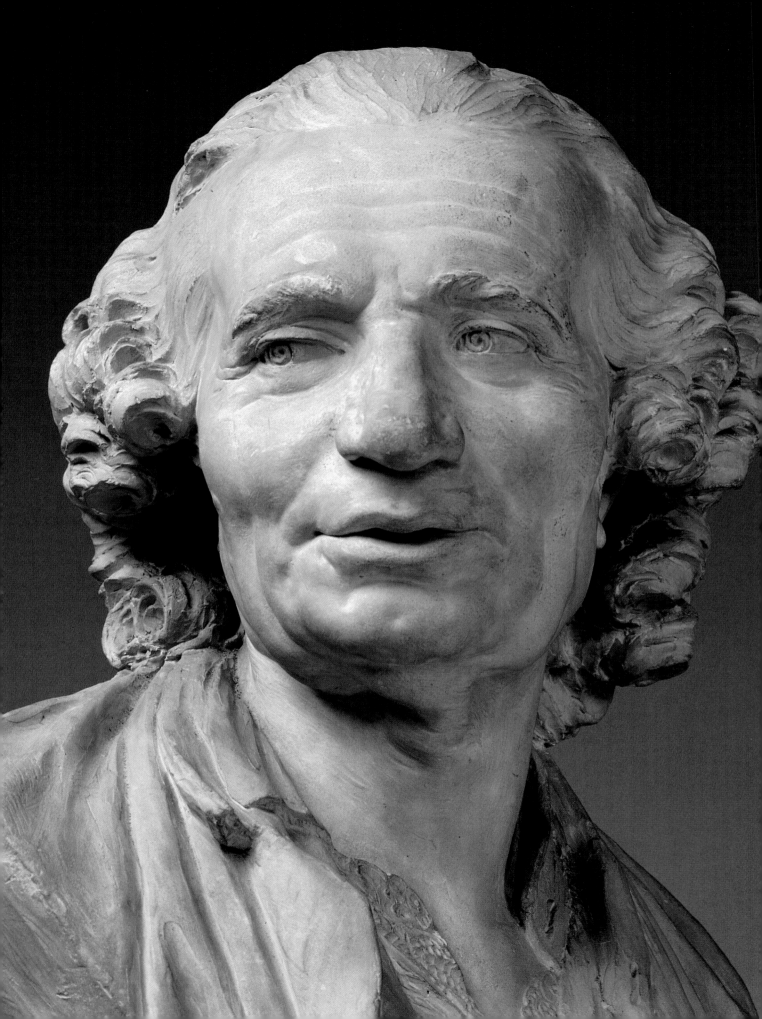

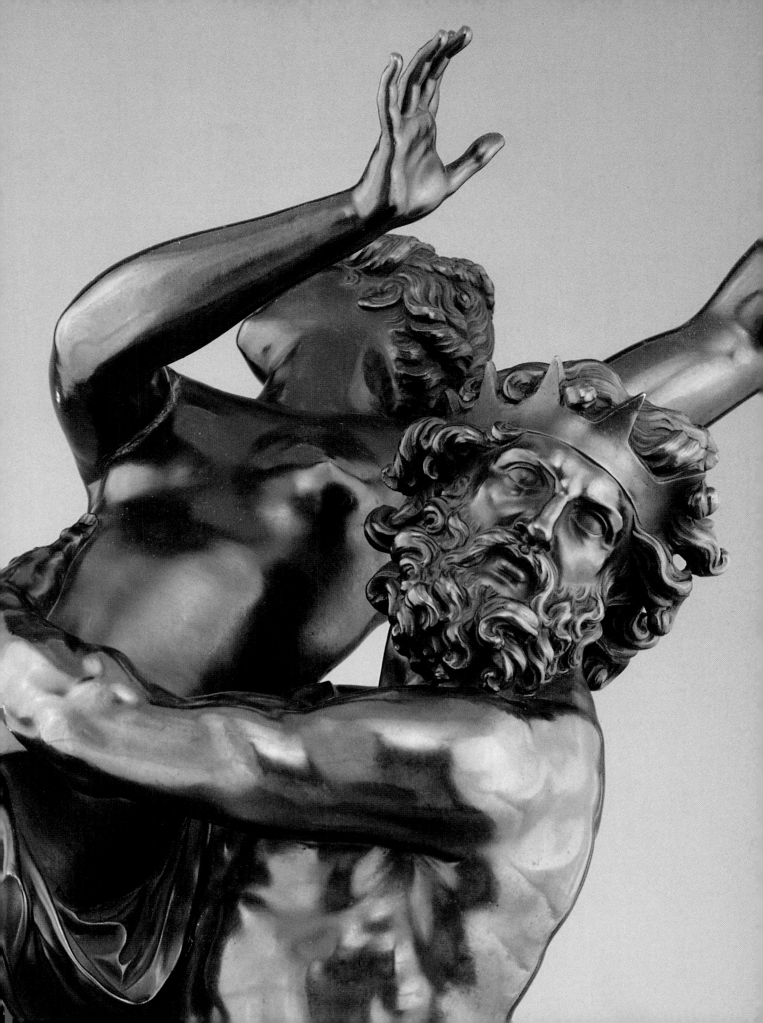

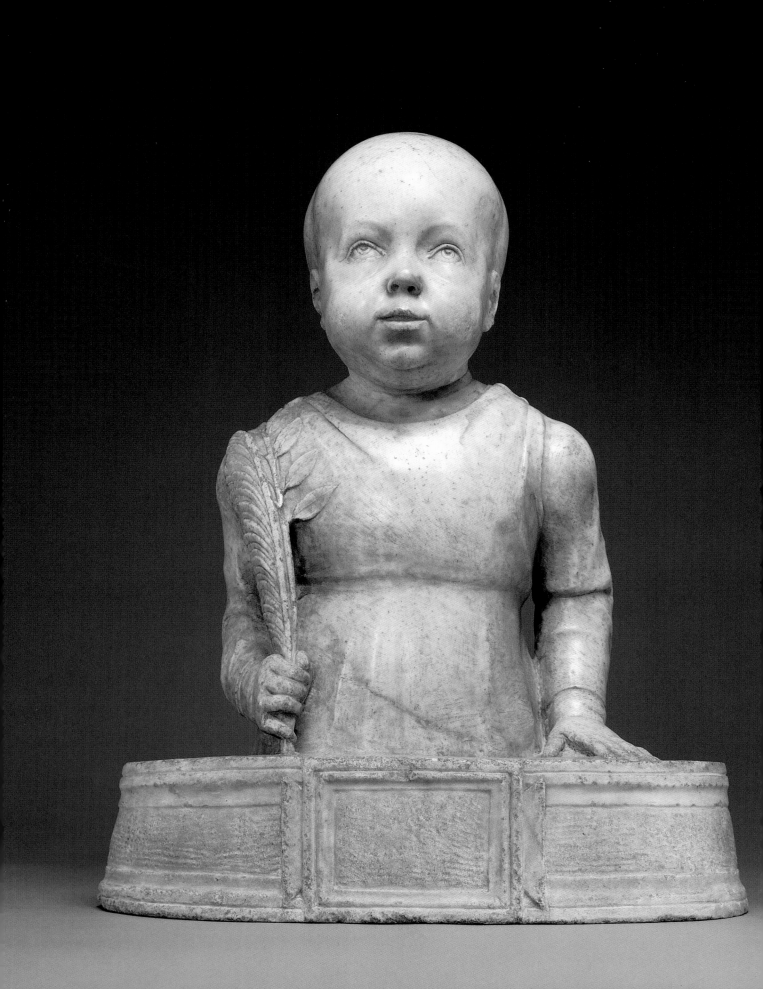

1 FRANCESCO LAURANA
Dalmatian (active in Naples,
Sicily, and Provence), 1420–1502
Saint Cyricus, circa 1470–1480

Marble
49.5 cm (19½ in.)
96.SA.6

Neither a bust nor a full figure, this work depicts the half-length image of an infant who holds a palm and a laurel branch, symbols respectively of martyrdom and of victory over death. The high oval base—with its scored, roughened areas meant to be covered with stucco and painted—is unusual and is particular to the works of Francesco Laurana. Born in Dalmatia, Laurana was an itinerant artist who worked in Italy and in southern France (Provence); he remains an enigmatic figure whose work ranges widely in quality but includes a series of idealized female portrait busts that are among the most sublimely beautiful sculptures produced in the fifteenth century.

Laurana's *Saint Cyricus* is a recent discovery that expands the previously established parameters of fifteenth-century sculpture. It is the only known half-length figure in the round with its own base carved from the same block of marble. In it, Laurana combines elements from other types of religious sculpture that contribute to its air of sanctity. The startling eyes raised to heaven are found in earlier images of saints and the suffering Christ. The combination of a high base and a horizontally truncated figure recalls reliquary busts, and the figure's half-length is previously found in the depiction of saints, the Virgin, and the Annunciate Angel.

According to legend, Saint Cyricus was martyred in circa 304 for refusing to pray to false idols. Various accounts provide a panoply of tortures to which the child was subjected, and some of these are evoked by the Getty marble. That he is shown half-length probably alludes to his having been cut in half (he became the patron saint of both sawyers and children). His torso is set inside, rather than on top of, the oval base, thus referring to the tradition that he was immersed in a boiling cauldron. The skull-like quality of his cranium probably recalls the legend that the skin was peeled back from his head. While the work conveys these gruesome elements, the artist has at the same time exploited the shape of the infant's cranium (surely based on direct observations from life) to create a beautiful abstract form that gives the sculpture a strange, otherworldly presence. PF

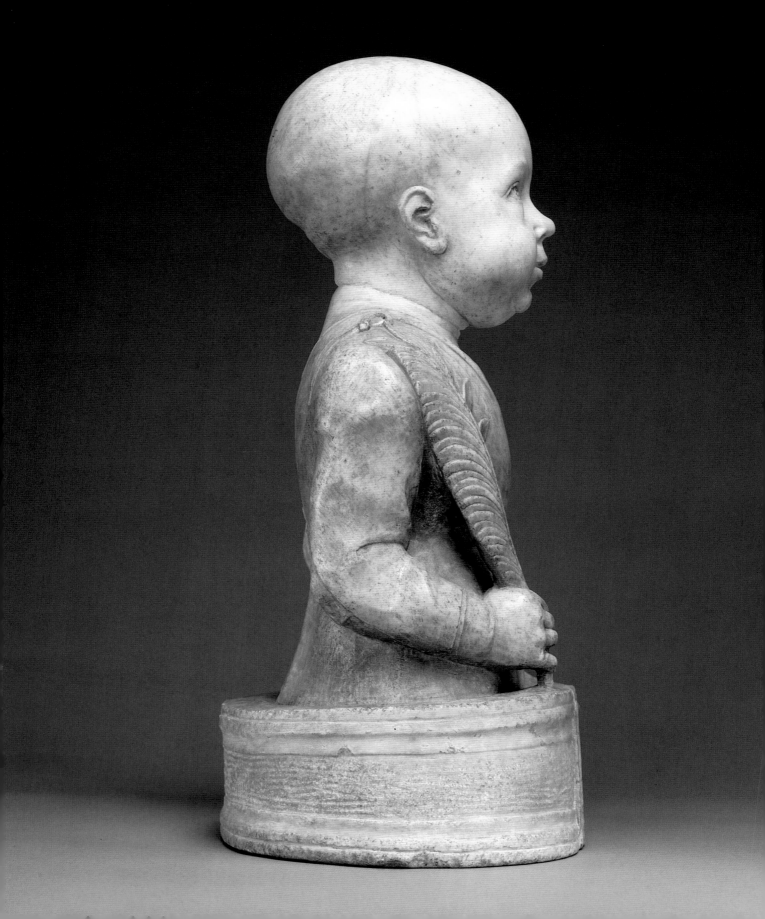

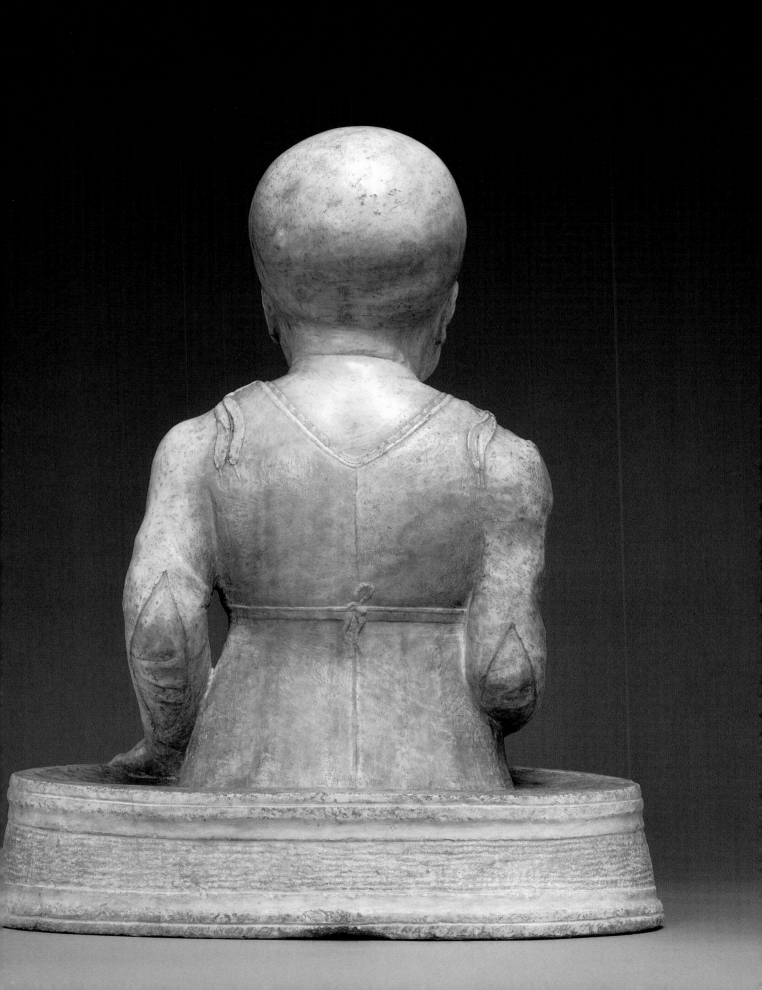

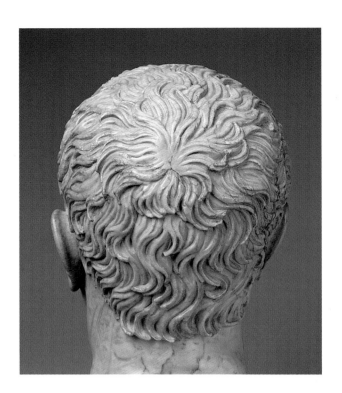
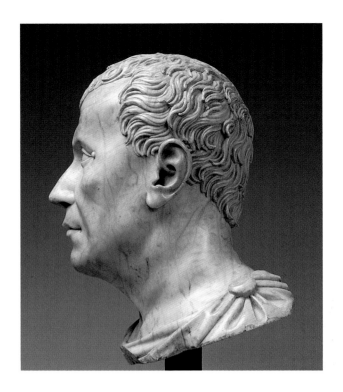

2 CONRAT MEIT

German (active in France, Brabant, Mechelen, and Antwerp), 1480s?–1550/51

Head of a Man (possibly a portrait of Cicero), circa 1520

Alabaster

33 cm (13 in.)

96.SA.2

Born in Worms, Meit was in Wittenberg by 1511, working for the Saxon elector Friedrich the Wise, who also employed Albrecht Dürer and Lucas Cranach the Elder. Around 1512 the sculptor moved permanently from Germany, and in 1514 he became official court sculptor to Margaret of Austria (1480–1530), regent of the Netherlands, in Mechelen. In 1526, Meit began work on his first monumental undertaking, the tombs of Margaret, Philibert, and Philibert's mother, Margaret of Burgundy, in the Church of Saint Nicolas de Tolentin in Brou. These tombs, together with a signed alabaster statuette of *Judith*, provide a secure foundation for the assessment of Meit's style and the attribution of works to him.

This alabaster *Head* represents a man of mature age. His hair, rendered in unusual, spaghetti-like strands, is combed forward toward his face. In addition to the concavity of his forehead and cheeks, the subject's most striking feature is the prominent mole or wart at the outer corner of the proper left eye.

The lack of contemporary references in the costume, the togate chest, and the arrangement of the hair at the crown in a "starfish" pattern that emulates antique portrait sculpture, all suggest that the *Head of a Man* is an *all'antica* depiction of an ancient figure. It may represent Marcus Tullius Cicero (106–43 B.C.), the famous Roman orator, lawyer, politician, and poet. Since no portraits of Cicero were known in the Renaissance, sixteenth-century artists were forced to invent their own iconography for the depiction of this well-known statesman. According to Plutarch ("Cicero," *Lives* 1.4), Cicero's family name—derived from *cicer*, or chickpea in Latin—originated with an ancestor who had a cleft in his nose that resembled a garbanzo bean. Apparently, Renaissance antiquarians interpreted this physical peculiarity as a wart or mole and associated it with Marcus Tullius himself. The wart, which could appear anywhere on the face, came to serve as the identifying attribute for portraits of Cicero.

PAF and PF

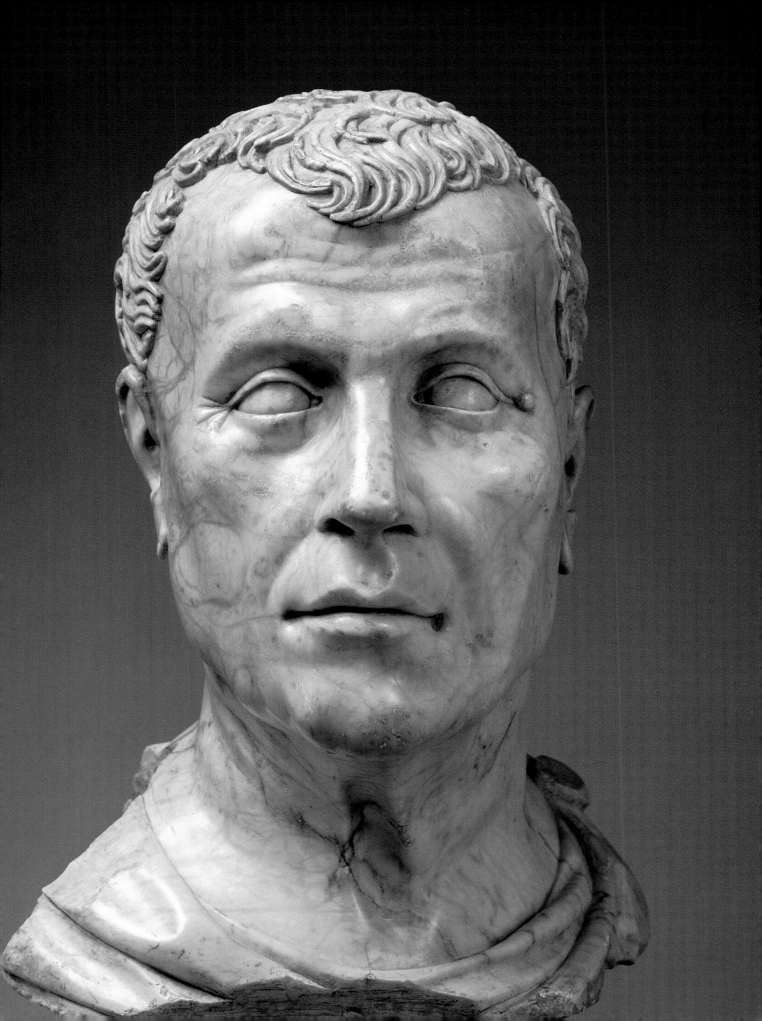

3 PIER JACOPO
 ALARI-BONACOLSI
 called Antico
 Italian (Mantua)
 circa 1460–1528
 Bust of a Young Man, circa 1520

 Bronze with silver eyes
 54.6 cm (21½ in.)
 86.SB.688

Originally trained as a goldsmith, Pier Jacopo became the principal sculptor at the court of Mantua in the late fifteenth and early sixteenth centuries. His restorations of ancient fragments, as well as his numerous bronze reductions and copies of famous statues and busts from antiquity, earned him the nickname Antico, meaning antique. Antico's emulation of ancient art extended not only to the forms and subjects of his compositions but also to his technique. For instance, in the Museum's sculpture, the silver eyes and excavated pupils—which give the bust such an arresting presence—recall ancient bronzes in which inlaid silver and copper were used to accentuate certain anatomical features and add coloristic variety. In other works Antico gilded the hair, drapery, or other details of the costume to create striking contrasts between the bright gold and the dark, patinated bronze.

The Museum's bust depicts a man in early adulthood, sporting a smooth mustache, close-cut sideburns, a hint of facial hair below the lower lip, and an abundant mass of curly hair that twists and spirals in all directions. The bronze is closely based on an ancient marble bust now in the Hispanic Society of America in New York. Although the identity of the subject of the marble portrait is uncertain, it was likely thought in the sixteenth century to represent a Roman emperor. Antico may have copied it in bronze as part of a series of emperor busts to decorate a palace interior or grotto. Antico's erudite patrons would have keenly appreciated the bust's visual reference to antiquity, in addition to the outstanding quality of the bronze and its precisely finished details.

PAF

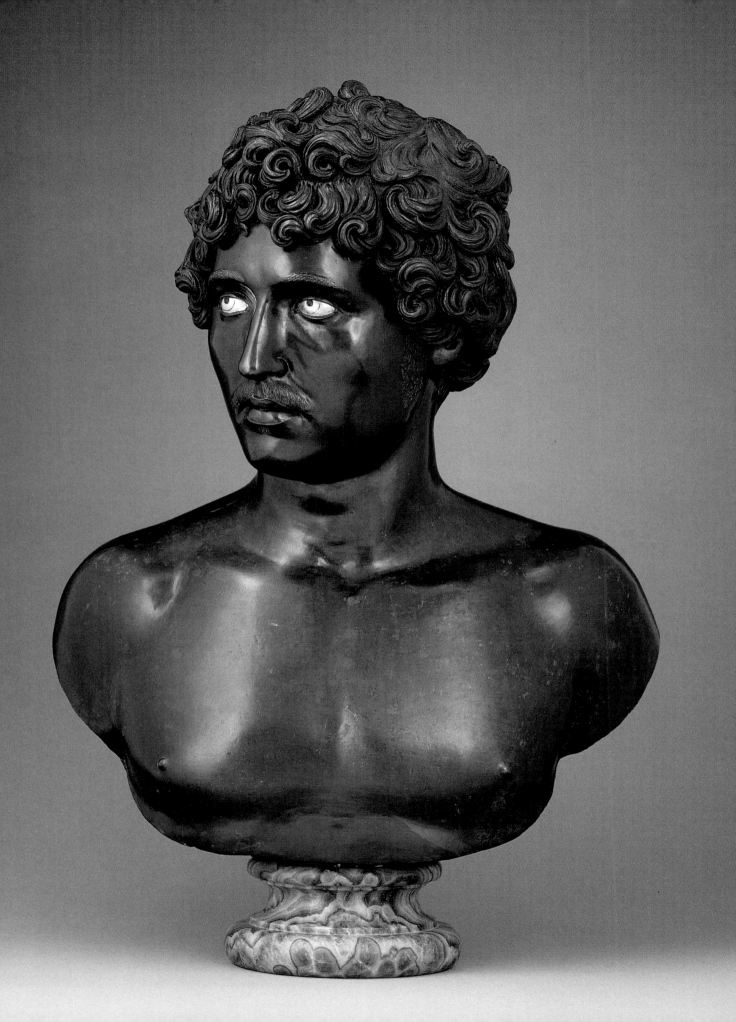

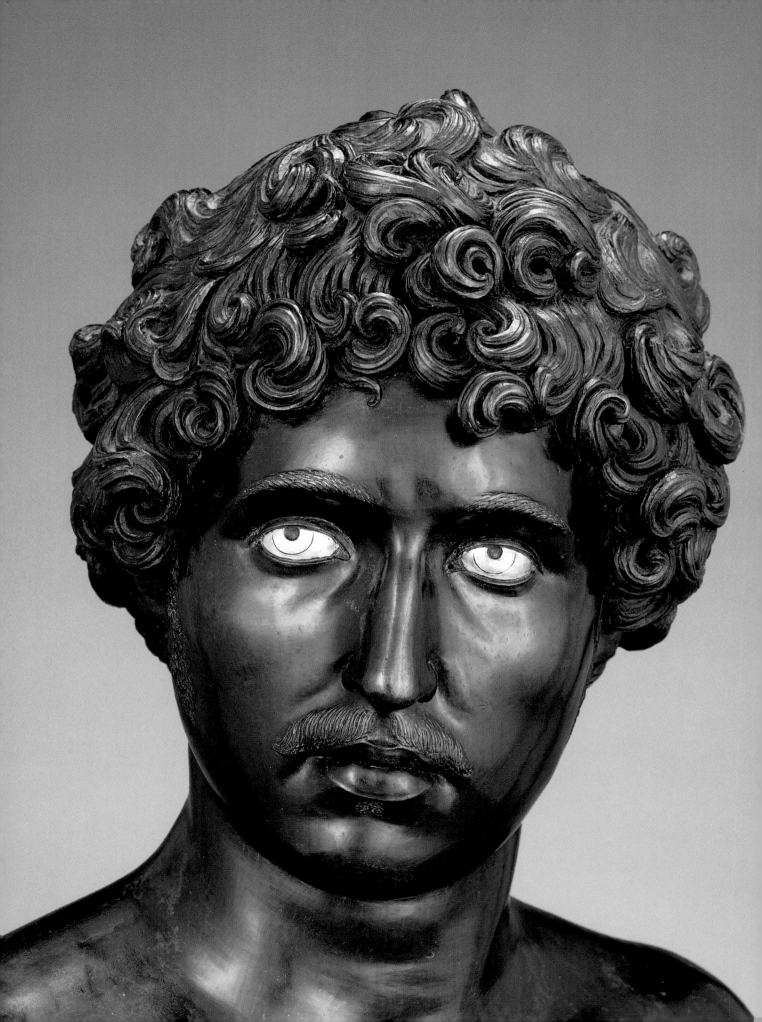

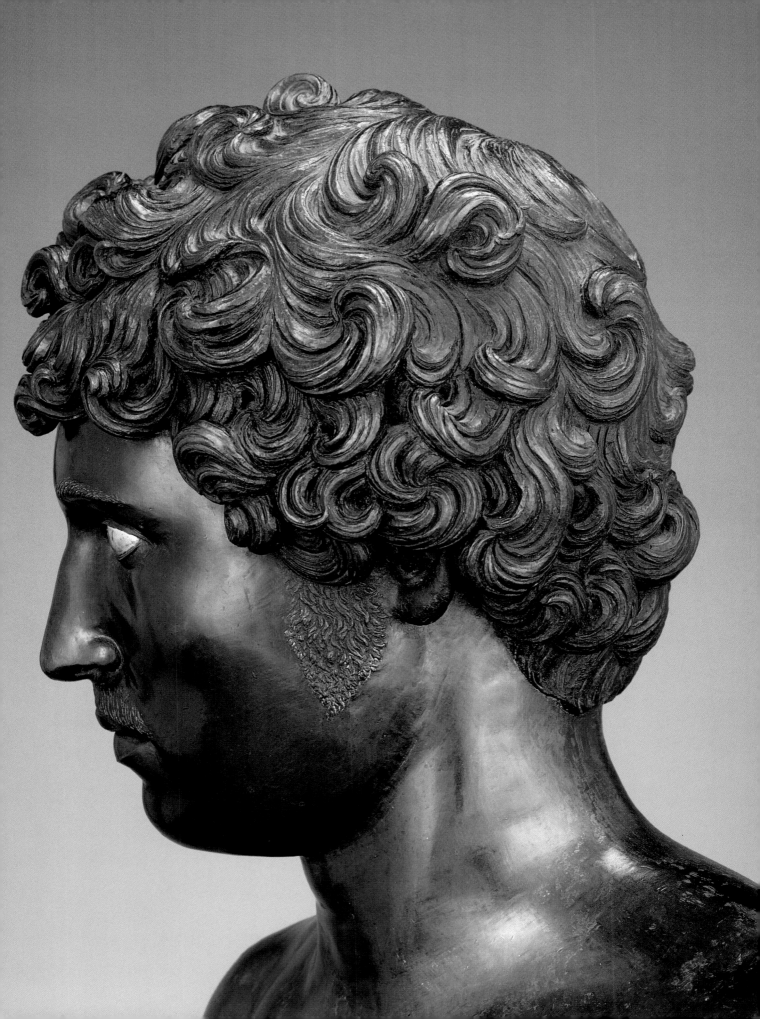

4 GIROLAMO
 DELLA ROBBIA
 Italian (born Florence,
 active in France), 1488–1566
 Bust of a Man, 1526–1535

 Tin-glazed earthenware with black
 underglaze accents on the eyes
 46.4 cm (18¼ in.)
 95.SC.21

This bust depicts a handsome, bearded male dressed in Roman-style armor and toga and rendered in three-quarter relief. The classical costume suggests his identity as an ancient Roman or Gallic hero. The bust belongs to a series of portraits produced by Girolamo della Robbia for the Château d'Assier near Figeac, northeast of Toulouse, in the south of France. The castle was built by Jacques, called Galiot, de Gourdon de Genouillac (1465–1546), a celebrated soldier and military official in the court of François I. The decoration of the building was begun in 1526 and completed by 1535. The design, known from engravings, incorporated relief portraits set into the walls of the courtyard. Like the other sculptures in this group, the Museum's bust was glazed white to imitate marble and would have been framed in a round, wreathed medallion. Its high-relief projection and bright reflective surface would have created a striking contrast with the flat, gray wall on which it was placed.

Girolamo was trained by his father in the Della Robbia workshop in Florence, famous from the 1440s for its production of glazed terracotta sculpture. The Museum's bust exemplifies Girolamo's particular approach to this medium, in which the expressive, naturalistic modeling of sculptural volumes and anatomical features—seen here in the strong nose, sunken eyes, and delicately furrowed brow—takes precedence over polychrome glazing and ornament. Girolamo may have left Florence to serve the French king and his court as early as 1517. Preceding other Italian artists recruited by François I, Girolamo was a pioneer in spreading the influence of the Italian style and establishing a more international reputation for Della Robbian art.

PAF

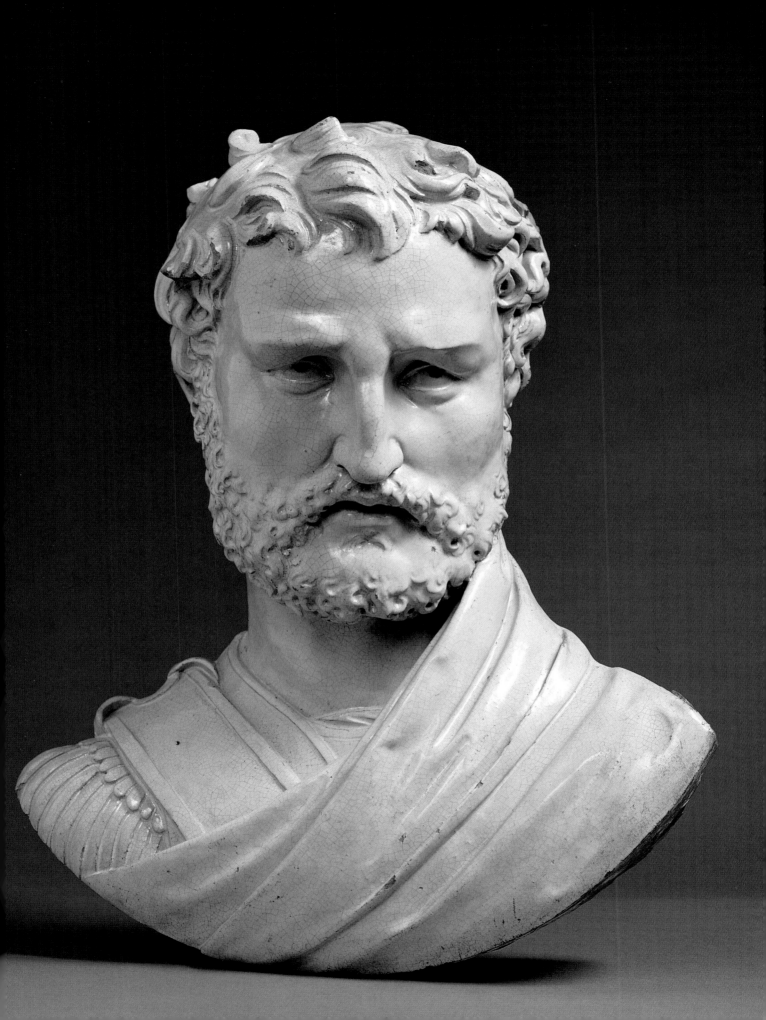

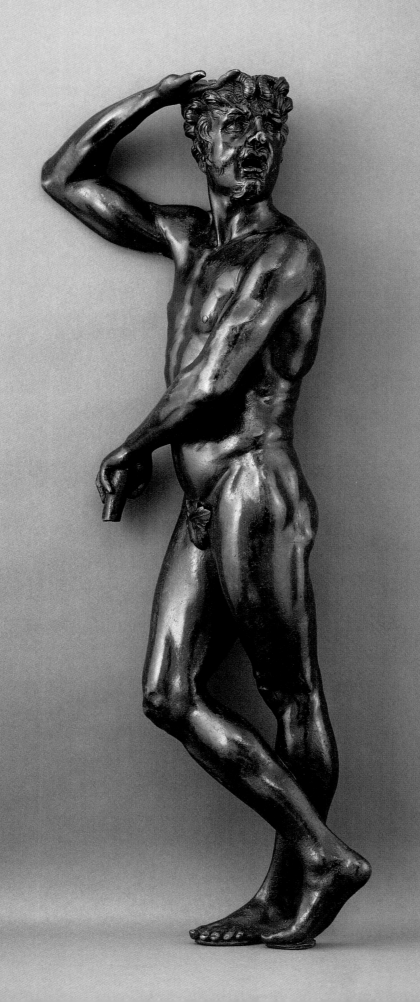

5 After a model by
BENVENUTO CELLINI
Italian (Florence, also active
at Fontainebleau), 1500–1571
Satyr
Cast after a model of circa 1542

Bronze
56.8 cm (22⅜ in.)
85.SB.69

According to ancient Greek mythology, satyrs were spirits of the woods and mountains, identifiable by their goatlike features including hairy legs and hooves, tails, bearded faces, and horns. In the Renaissance they were often associated with lust and other primal passions. In his unique conception of a satyr, Cellini tempered the traditional bestiality of its physique—giving the creature a fully human body and retaining only its small horns and goatish head—but emphasized its psychological aggressiveness. Cellini's *Satyr*, sculpted in more than half-relief, stands in exaggerated contrapposto and turns its head sharply to its left, gazing fiercely—with a furrowed brow, gnarled lips, and open-mouthed scowl—toward an unknown intruder.

The Museum's bronze *Satyr* was cast from a wax study for Cellini's project to remodel the entrance of the French royal palace at Fontainebleau. Called the *Porte Dorée*, or "Golden Door," the plan called for a pair of satyrs to flank the doorway and to serve as vertical supporting elements, holding up the cornice. Above there was to be a semicircular relief depicting a nude female nymph, surrounded by animals of the forest that served as emblems of François I. The project was never completed, and the wax model for the *Satyr* may have remained in Cellini's French studio after the artist returned to his native Florence. PAF

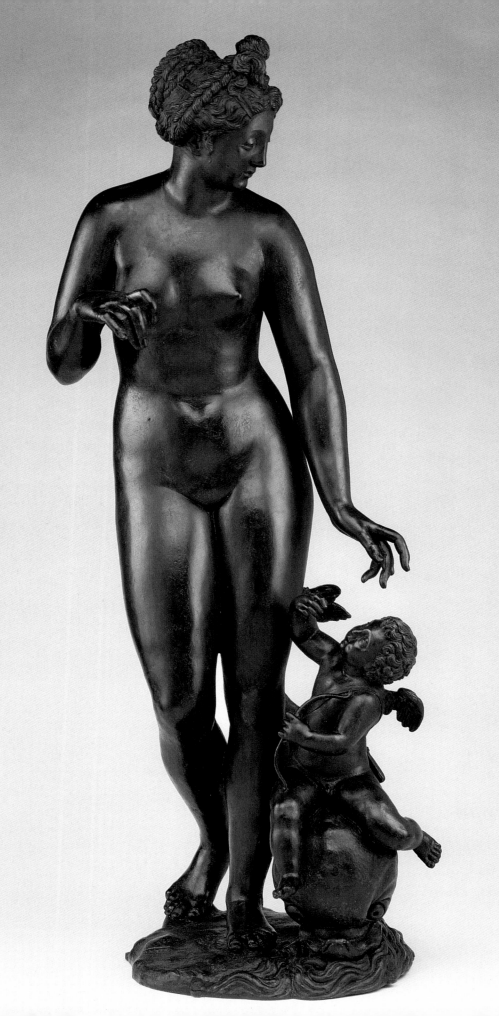

6 Circle of
JACOPO SANSOVINO
Italian (active in Florence,
Rome, and Venice), 1486–1570
Venus and Cupid with Dolphin,
circa 1550

Bronze
88.9 cm (35 in.)
Inscribed under the base: *F⁺B*
(founder's mark?)
87.SB.50

Venus, with her full-bodied limbs and straight-nosed *all'antica* profile, reveals the artist's awareness of antique models. The sharp turn of her head to the left may be inspired by the famous *Venus de Medici;* however, the Museum's figure does not completely follow any single prototype. Almost all the famous antique statues of Venus are shown with hands raised and positioned to hide the goddess's nakedness or to lift drapery in some feigned gesture of modesty. The "non-*pudica*" aspect of the bronze is startling by contrast.

The *Venus* is similar to the High Mannerist works executed in the 1540s and 1550s by Italian artists such as Francesco Primaticcio and Jacopo Sansovino. The bronze finds its closest stylistic parallels in the works of Sansovino, who is documented as having executed two figures of Venus (now lost). Although no known nude female figures by him have survived, Sansovino's extant documented works exhibit several elements found in the Getty bronze: the unusually abstract treatment of the eyebrows, delineated by a single, sharp, semicircular line that continues down to define the bridge of the nose; the thin, slit eyes; the relatively small, slightly twisted mouth; the elaborate coiffure with knobs of hair projecting up above a circular braid; the pair of barrettes (which are identical to those in Sansovino's figure of *Charity* on a monument to Doge Francesco Venier in the Church of San Salvatore, Venice); the figure's elongated limbs and very substantial upper arms and thighs; the large but elegant hands and feet; and the unusual position of the nose-diving dolphin with the series of distinct bumps running up over its head and back (very like the dolphin accompanying Sansovino's giant figure of *Neptune* in the courtyard of the Doge's Palace, Venice). Also similar to Sansovino's works is the treatment of Venus's hands, which are bent at the wrists in an affected, mannered fashion, with the fingers splayed open like a pinwheel. It seems probable that the cupid in the Museum's work originally held up a now-missing arrow, the sharpness of which Venus was testing with the tip of a finger. This would have added to the sense of aloof, disdainful, and icily dangerous sensuality that permeates the work.

PF

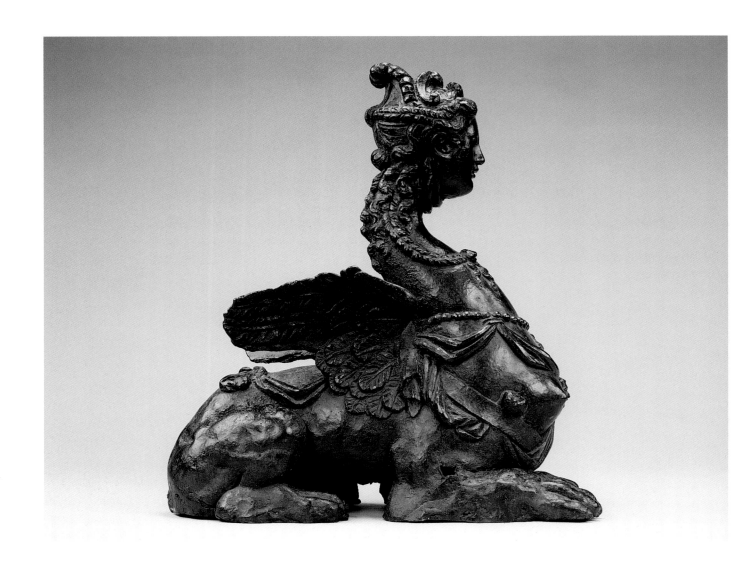

7 *Sphinx*
Italian (Florence), circa 1560

Bronze
64 cm (25³⁄₁₆ in.)
85.SB.418.1

The sphinx is a creature of fable, composed of a woman's head and chest, a lion's body, and an eagle's wings. She is depicted crouching on all fours, with heavy-lidded eyes and her head pulled back—like a snake about to strike—over a long, bejeweled, curving neck that leads down to large projecting breasts proffered to an unsuspecting victim. The overall impression conveyed is of a cool, threatening sensuality. Her exotic allure, combined with the elaborate coiffure, sinuous forms, and fantastic imagery, is typical of much Florentine Mannerist art and finds close sculptural parallels in the work of Benvenuto Cellini and Vincenzo Danti.

Of Egyptian origin, the sphinx also appears in Greek and Roman art as a symbol of voluptuousness, intelligence, and mystery. In the Renaissance, this creature was associated with fire and death, and often ornamented chimneys and tombs. The illustrated figure is one of a pair in the Museum's collection. Both have roughly hammered surfaces on the front and areas of the sides, and both were left unfinished (without any chasing after casting) on their backs and on the tops of their wings. This suggests that they were only meant to be seen from below. They were probably intended to support the front corners of a sarcophagus on a tomb. PF

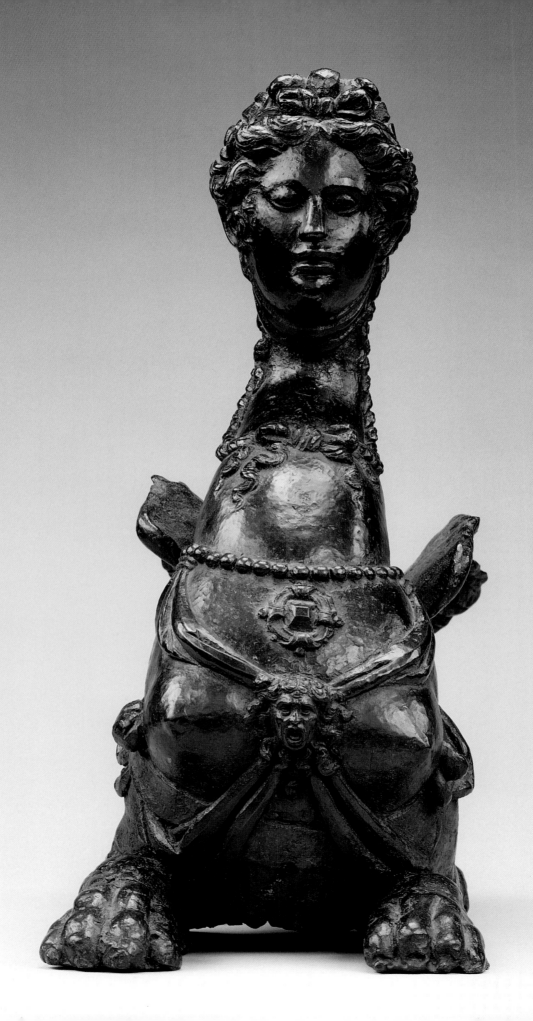

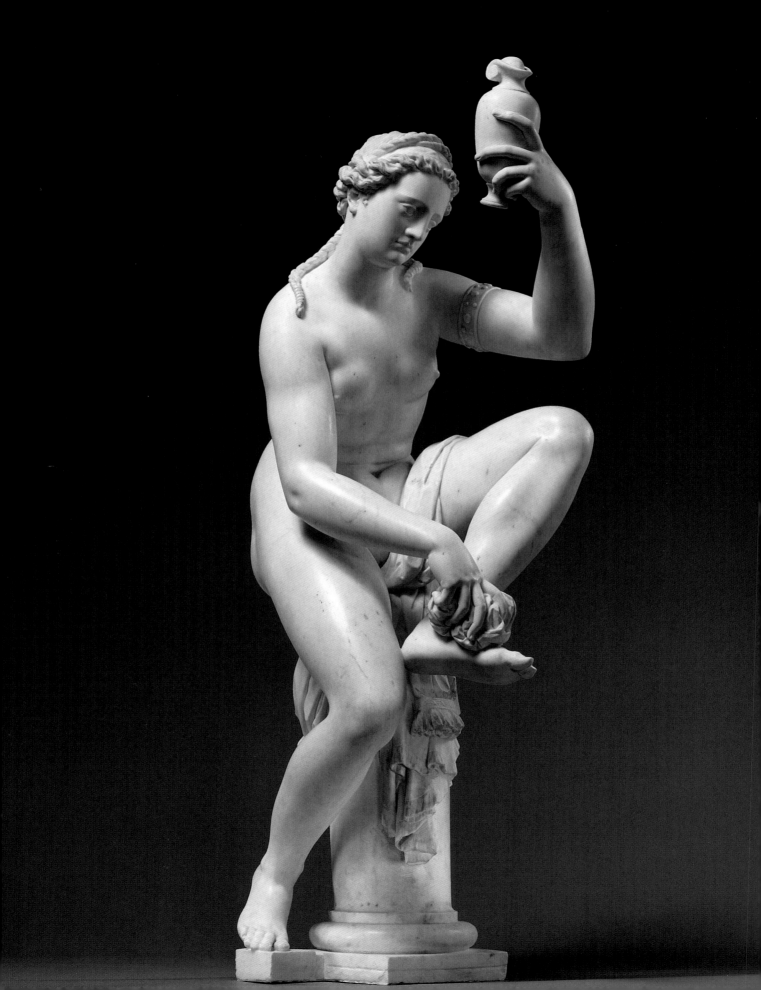

8 GIOVANNI BOLOGNA
 (Jean Boulogne),
 called Giambologna
 Italo-Flemish (born Douai,
 active Florence), 1529–1608
 Female Figure (possibly Venus,
 formerly titled *Bathsheba*),
 1571–1573

 Marble
 114.9 cm (45¼ in.)
 82.SA.37

Working in Florence as an official court artist to the Medici dukes, Giambologna was the most prominent and innovative sculptor during the Mannerist period of the late sixteenth century. This marble female figure exemplifies the characteristic features of his style. The figure's pose conforms to an upward spiral, called a *figura serpentinata*, in which a twisting torso and bent limbs suggest a graceful, if artificial, s-shaped curve in three dimensions. She is not quite seated, with one side of her buttocks completely unsupported, but not quite standing, as she reaches down with her right hand to dab her foot with a small cloth and raises her left hand to hold a vessel above her head. With one leg and both arms positioned in front of her, her balance is tilted precariously forward. For Giambologna, the naturalness of the pose was less important than its elegant and pleasing silhouette, meant to be seen from several angles. The cool appeal of the figure's smooth, naked body is offset and emphasized by her tightly braided, coiled hair and the crisp folds of a discarded blouse or robe whose sleeve is draped across her groin.

Giambologna's figure may be identified with a marble statue sent by the Medici to the duke of Bavaria as a diplomatic gift. The subject of this marble was not mentioned by Giambologna's early biographers, but the statue likely represents Venus, a common subject for a nude female figure depicted bathing. In the seventeenth century, according to documents, the marble was taken to Sweden by King Gustav Adolph as booty during the Thirty Years' War with Germany. By that time the statue had been renamed *Bathsheba*, presumably in order to invest the figure's nudity with biblical significance during the Counter-Reformation. The figure remained in Sweden until the late twentieth century. A series of interconnecting channels inside the figure, running from the vessel in her raised hand down through the base of the column on which she sits, suggests that the marble once served as a fountain. The figure's hands and feet were damaged in the eighteenth century; the top of the vessel and portions of the left hand are incorrect, twentieth-century restorations. PAF

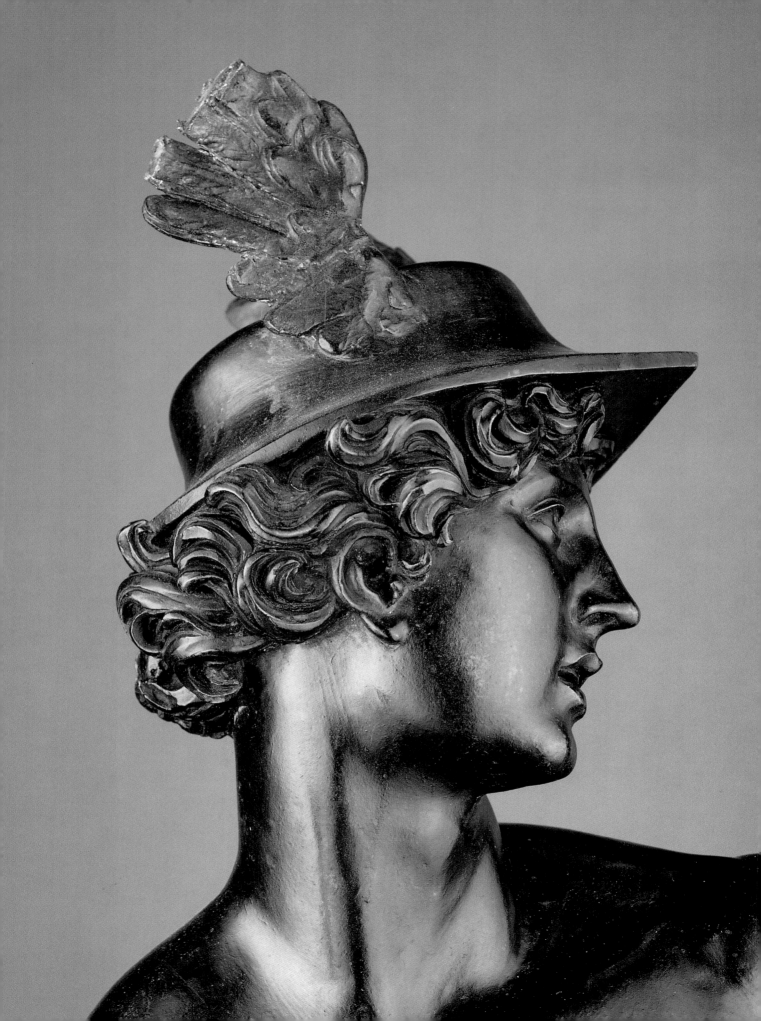

9 JOHANN GREGOR VAN DER SCHARDT
Dutch (active in Venice, Vienna, Nuremberg, and Denmark), circa 1530–1581
Mercury, circa 1570–1580

Bronze
114.9 cm (45¼ in.)
95.SB.8

This bronze represents Mercury, the divine messenger of the gods and patron of travel, science, commerce, and thievery. Wearing only his winged helmet and sandals to convey the speed with which he traverses the heavens, the athletic young god steps forward, holding in his right hand the caduceus, his magic staff. He turns his head, his gaze following the movement of his extended left arm. Mercury speaks, with open mouth and articulate gesture, embodying the ideal of eloquence. A version of the *Mercury* of the same design and size in the Stockholm Nationalmuseum, signed *I.G.V.S.F.* for "Ian Gregor Van Sart Fecit" (Johann Gregor van der Schardt made it), secures the attribution of the Getty bronze to Schardt. The *Mercury* can be traced to the collection of Paul Praun (1548–1616), a Nuremberg patrician and avid collector of Schardt's work, though it is uncertain whether Praun acquired it before or after the artist's death in 1581.

Schardt, a native Dutchman, spent the early years of his career in Italy, where he studied and copied famous antique and Renaissance statues and absorbed the classicizing and Mannerist ideals of contemporary sculptors like Jacopo Sansovino, Benvenuto Cellini, and Giambologna. He was one of the first artists to bring these ideas to Northern Europe, working in the courts of Nuremberg, Vienna, and Denmark in the 1570s. Schardt either was unaware of or rejected the most famous contemporary rendering of Mercury by Giambologna, who shows the god in flight: poised on one foot, with limbs extending into space, and meant to be seen from all angles. In contrast, Schardt's *Mercury* is based on one of the most famous ancient statues, the *Apollo Belvedere*, a figure planted firmly on the ground. Schardt refined the composition of the revered model by elongating the limbs, torso, and neck of the figure and emphasizing the graceful, swaying lines and easy harmony of the body in motion.

MC

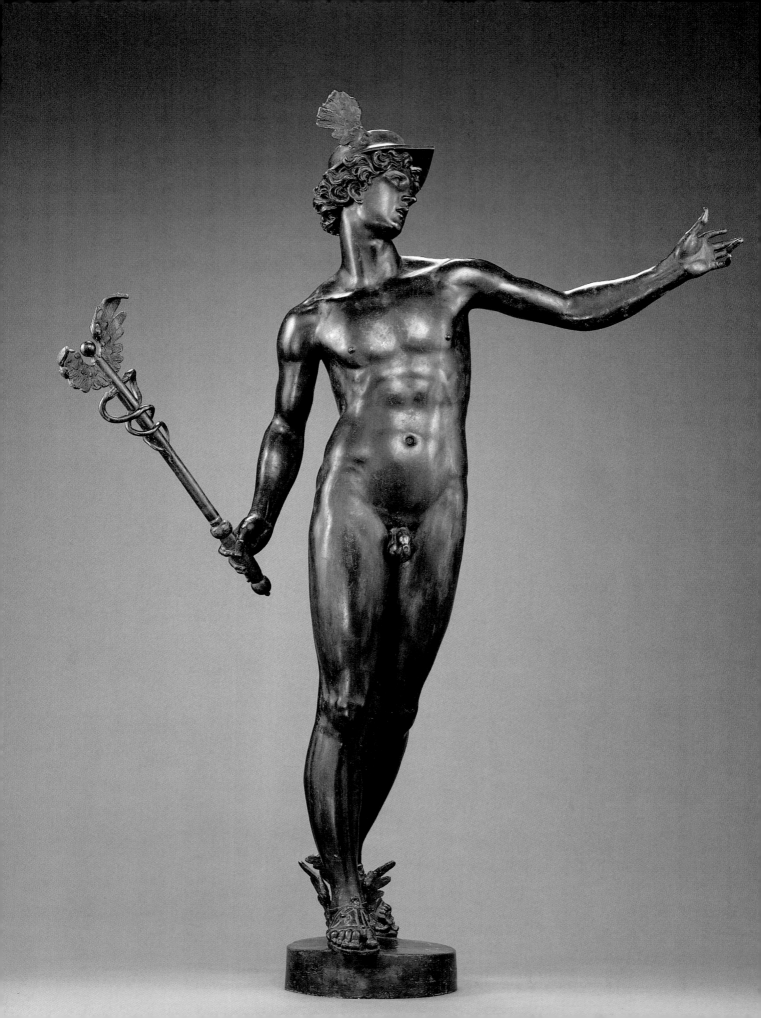

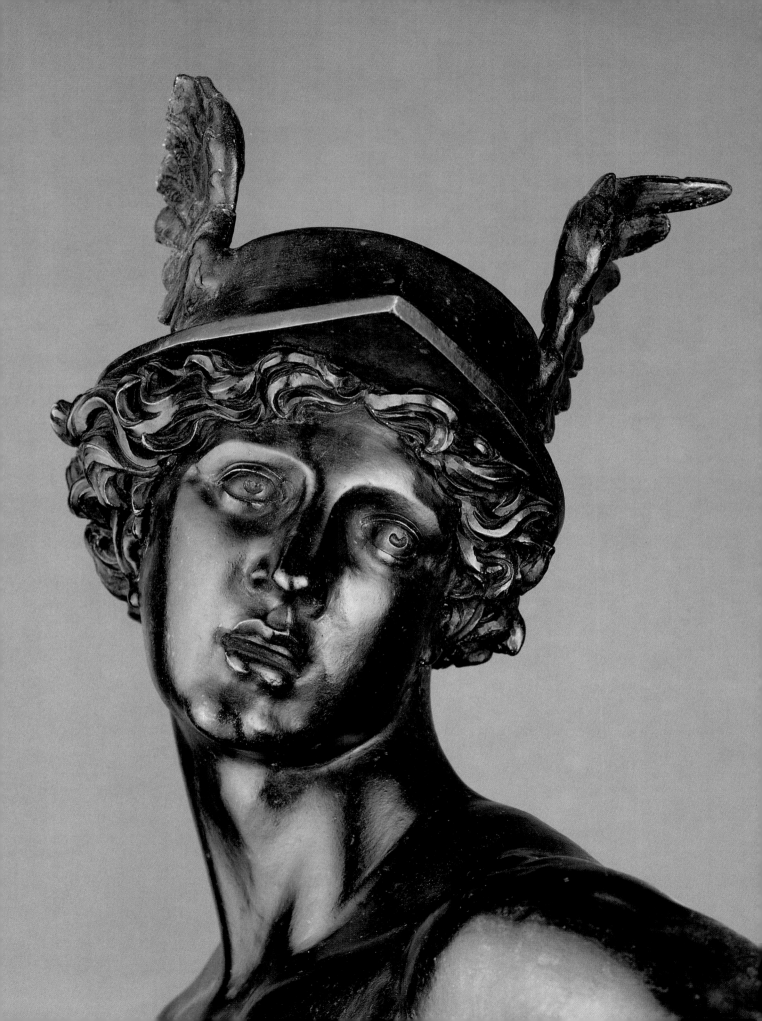

10 CESARE TARGONE

Italian (active in Rome,
Florence, and Venice),
active late sixteenth century
*The Virgin Mourning the
Dead Christ*, 1586–1587

Repoussé gold relief
on an obsidian background
Gold relief: 28.9 x 26 cm
(11⅜ x 10¼ in.)
Obsidian background: 38.4 x 26.5 cm
(15⅛ x 10⁷⁄₁₆ in.)
Inscribed below Christ's feet:
OPVS. CESARIS. TAR. VENETI
84.SE.121

This relief is the only known signed work by the Venetian goldsmith Cesare Targone, who also worked in Rome and Florence and served as a dealer in antique gems for prestigious patrons like the Medici grand dukes. For Ferdinando I de' Medici, Targone produced gold reliefs based on models by Giambologna to be set on exotic stone backgrounds of green jasper and amethyst. These were part of the decoration of the famous "Tribuna," an octagonal room in the Uffizi, Florence, built to display famous works of art and precious objects owned by the Medici. *The Virgin Mourning the Dead Christ* would have fitted well into such a collection because of its rare, costly materials, its small scale, and the virtuosity of its execution. It is a masterful example of gold repoussé technique, in which a thin sheet of gold is pressed over a model or is worked manually from behind to create forms in relief. The goldsmith then worked the soft material from the front, refining details and creating a variety of textures, seen here, for example, in the hair and beard of Christ and the mossy ground upon which he lies. The setting of the brilliant gold relief on to black obsidian (a volcanic glass) heightens the effect of splendor. The figures dominate the panel, creating an impression of monumentality that contradicts the relatively small scale of the object, increasing the sense of wonder.

The scene represents the Virgin, standing behind the body of the dead Christ, her hands clasped in a gesture of lamentation, her head turned in stark profile. Christ lies upon the winding sheet, his upper body supported by the sloping hillside, his eyes and mouth slightly open. The isolation of the two figures recalls the devotional image of the Pietà, in which the Virgin supports the body of her dead son on her lap. The standing Virgin and the body of Christ laid out on the ground are reminiscent of lamentation scenes in painting or sculpture that typically include many mourning figures. This relief combines and distills these sources, placing devotional focus upon the body of Christ and the restrained grief of the Virgin. The image seems timeless, the black background merely suggesting that the scene takes place during the darkest hours of the night. Similar episodes from the Passion of Christ are known in sketches and in reliefs in wax, bronze, and gold by, or associated with, Guglielmo della Porta (died 1577), the most important sculptor working in Rome after Michelangelo's death. MC

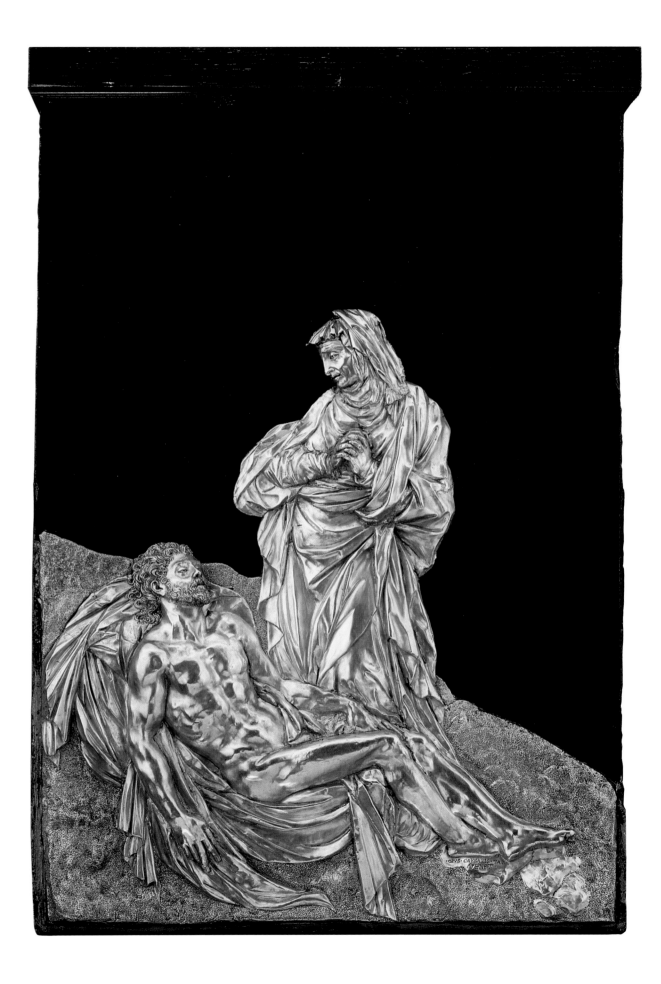

11 TIZIANO ASPETTI
Italian (active in Venice,
Padua, Pisa, and Florence),
circa 1559–1606
Male Nude, circa 1600

Bronze
74.9 cm (29½ in.)
88.SB.115

One of the most important late Mannerist sculptors, Aspetti was probably born in Padua, where from 1591 until 1603 he worked on a series of religious bronze sculptures for the Santo (the Church of Sant'Antonio) and the cathedral. Among the many secular or mythological bronze statuettes attributed to him, none is fully documented. The Getty work is one of the few that, on the basis of quality and stylistic analogies with documented work, can be ascribed to him with relative certainty. The *Male Nude* is particularly close in style to two of Aspetti's documented works: the marble male nude executed in 1590–1591 for the entrance hall of the Venetian Mint and a male figure in a bronze relief of *The Martyrdom of Saint Lawrence*, made in 1604–1605 for the Church of Santa Trinita in Florence. These works reveal a similar rendering of the male body shown in torsion, very muscular, with wide shoulders and hips, elongated limbs, proportionally small head, bearded face with fine nose, and elegant hands with long fingers.

Before it was acquired by the Museum, the *Male Nude* was sold at auction with a companion male nude figure (now in a private collection). The two bronzes do not appear to have been made as pendants or as the crowning figures of firedogs since they neither mirror each other in pose nor have triangular bases (both standard elements of late sixteenth-century firedogs). Instead, with their matching circular bases, the Museum's bronze and its companion were most likely intended as part of a series, perhaps to decorate a balustrade or scholar's study. Bearing no attributes to suggest a specific identity, the subject of the Getty's *Male Nude* remains uncertain.

Influenced by Michelangelo and Tintoretto as well as by Giambologna and Tuscan Mannerist painting, Aspetti developed his own lively, declamatory, *maniera* style with a very particular combination of force, elegance, and expressive energy. In the Museum's bronze, there is an exaggeration of individual muscles to produce a rippling effect of light and shadow across the surface and a series of sharply defined, undulating profiles. Twisted in a complicated pose that is nearly unbalanced and would be difficult "to hold," the figure's stance and lively, unusually expressive hands call to mind the eloquent exhortations of an orchestra conductor. PF

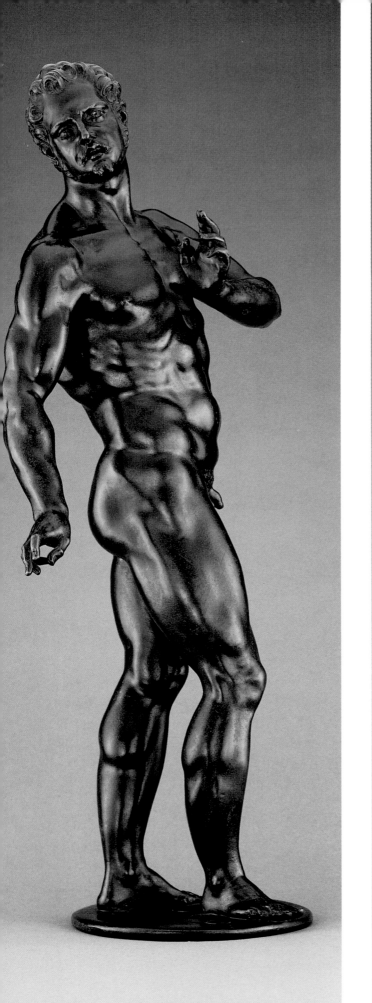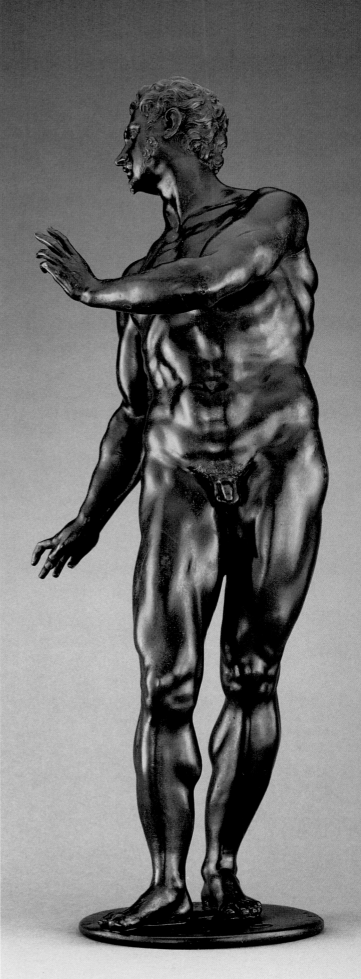

12 *Corpus*, circa 1600
Italian

Wood
32.5 cm (12¾ in.)
97.SD.45
Gift of Lynda and Stewart Resnick
in honor of Peter Fusco

This wood *Corpus* (the representation of the body of Christ crucified) presents a restrained and noble image of Christ's death on the cross. The crucified Christ, a central image in Christian iconography dating back at least to the fifth century, could be presented in a variety of ways, each of which conveyed certain messages or stressed particular aspects of Christian belief. Early representations, for example, show Christ on the cross alive, with eyes open, expressing his triumph over death. In the fourteenth century, an emphasis on Christ's suffering, calling attention to his humanity and the frailty of his human flesh, became more prevalent.

In fifteenth-century Florence, Filippo Brunelleschi carved a monumental crucifix (in the Church of Santa Maria Novella) that is the ancestor of this *Corpus*. He presented Christ dead but not suffering, with head dropped to the proper right, a straight muscular torso, and legs crossing only at the feet and shifted to the same side as the head. This idealizing image of Christ on the cross was further developed by sixteenth-century artists like Michelangelo and Guglielmo della Porta. In fact, the present *Corpus* is very close to a group of crucifixes and Crucifixion reliefs attributed to Della Porta. The placement of the limbs and head, the carefully modeled musculature of the torso and back, and the reserved depiction of Christ's death are all found in the Della Porta examples. The torso is truly frontal, with none of the contrapposto twisting of later, more animated images. The clinging loincloth reveals the anatomy of the body below it in the back view, which is distinctly different from most Baroque versions, in which the drapery takes on a life of its own. The quiet, contemplative quality of the Getty *Corpus* finds close parallels in late sixteenth-century Italian paintings, where sacred imagery is presented in a straightforward fashion in keeping with the precepts of the Council of Trent. The Getty sculpture has the timeless beauty of such images, which played an important role in devotional life in Counter-Reformation Europe.

MC

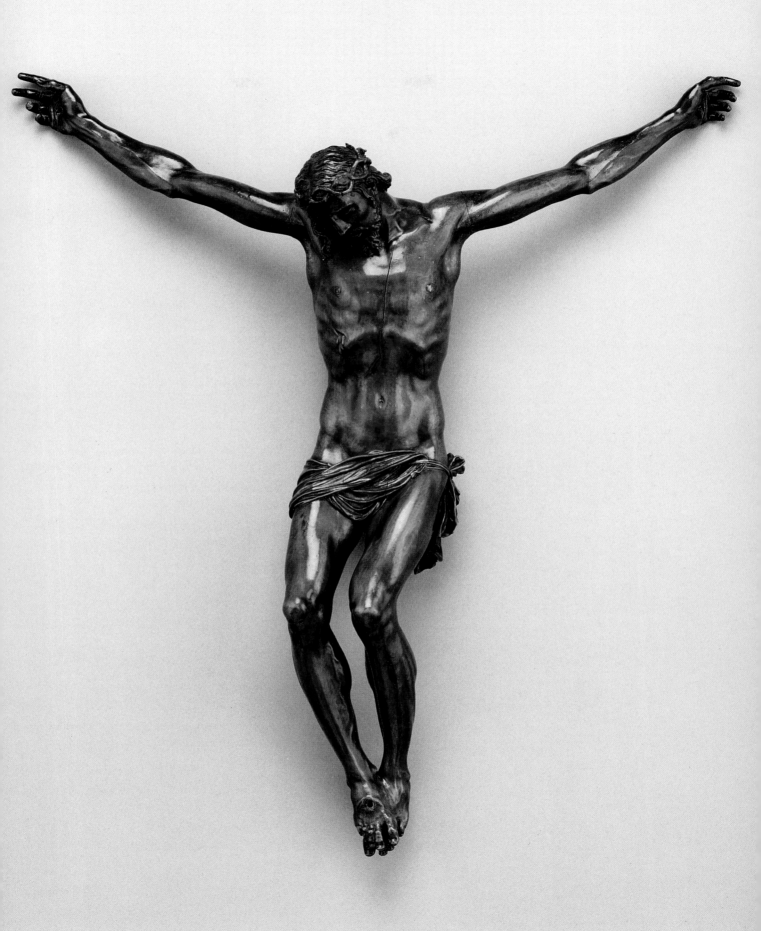

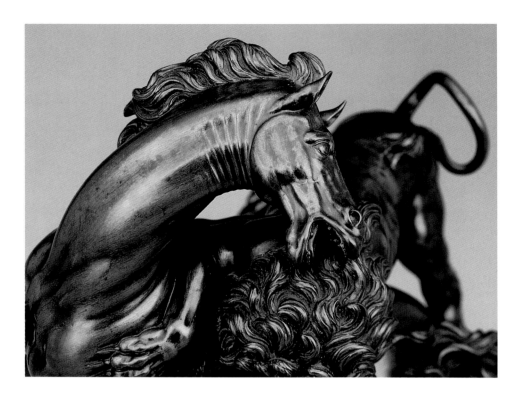

13 ANTONIO SUSINI
Italian (Florence),
active 1572–1624
or
GIOVANNI FRANCESCO
SUSINI
Italian (Florence),
circa 1585–circa 1653
After a model by Giovanni
Bologna (Jean Boulogne),
called Giambologna
Italo-Flemish (born Douai,
active in Florence), 1529–1608
Lion Attacking a Horse,
first quarter of the
seventeenth century
Bronze
24.1 x 28 cm (9½ x 11 in.)
94.SB.11.1

In this vivid scene of animal combat, a ferocious lion attacks a horse from the side, digging into its flesh with claws and teeth and forcing it to collapse upon the rocky ground. The horse, writhing in pain, twists its neck back toward the predator with an open-mouthed whinny. The circular rhythm created by the position of the horse's neck and tail serves to contain the composition and focus attention on the central, dramatic action of the lion biting into the horse's skin. The taut muscles and contorted poses of the animals within this compact grouping convey a sense of dynamic struggle and physical anguish. However, despite the brutality of the subject, the rich, golden-brown patina and exquisitely rendered details—for instance, the ripples along the horse's bent neck and the carefully punched whiskers on the lion's muzzle—transform this violent group into a precious, jewel-like object.

Giambologna, the pre-eminent sculptor in late sixteenth-century Florence, created the model for this group, which was then cast in bronze by one of his close associates. He derived the composition from a fragmentary ancient marble in the garden of the Palazzo dei Conservatori in Rome. The horse's front and hind legs, neck, and head, as well as the lion's rear legs and tail, were lacking in the marble sculpture when Giambologna would have seen it in the 1550s or 1580s. His bronze, therefore, represents a masterful solution to the restoration of an ancient fragment. The *Lion Attacking a Horse* was created as one of a pair of animal bronzes. The other group, depicting a *Lion Attacking a Bull*, is also in the Museum's collection. PAF

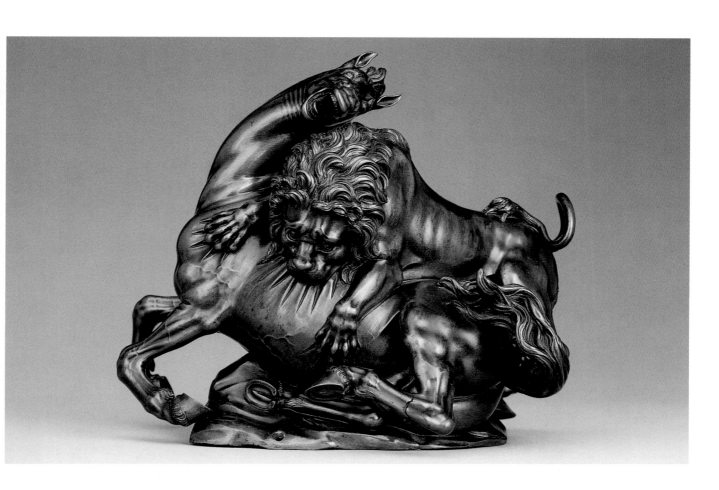

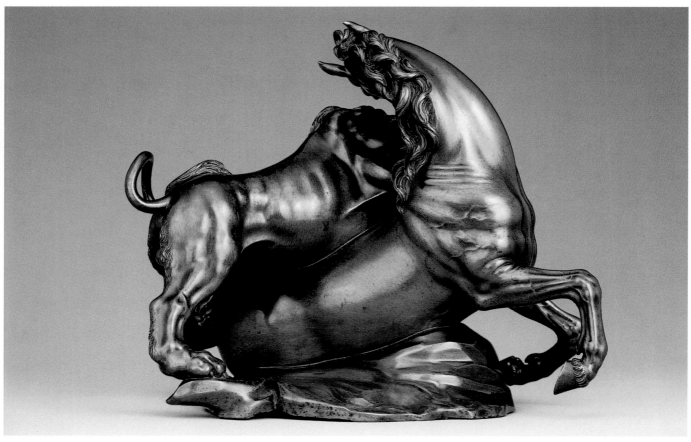

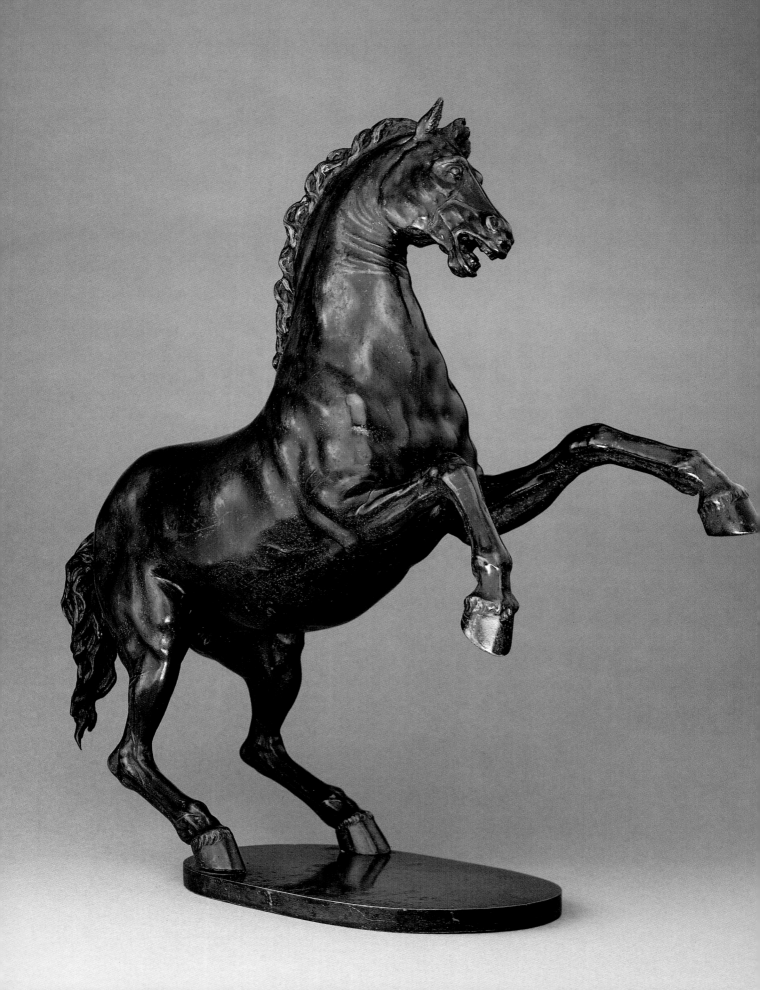

14 ADRIAEN DE VRIES
Dutch (active in Florence,
Milan, Augsburg, and Prague),
1545–1626
Rearing Horse, circa 1610–1615
Bronze
48.9 cm (19¼ in.)
Inscribed on the base: *ADRIANUS FRIES HAGUENSIS FECIT*
86.SB.488

The horse, or the horse and rider, was an extremely popular subject in European sculpture from the time of the Renaissance onward, perhaps because of its association with famous ancient monuments, such as the bronze equestrian statue of Marcus Aurelius in Rome. The earliest independent bronze statuettes of horses in the Renaissance were probably produced in northern Italy at the end of the fifteenth century. By the seventeenth century, technical advances in the art of bronze casting enabled sculptors to balance the weight of the entire composition on two of the horse's legs. Several primary concerns of the early Baroque aesthetic—sudden, violent motion, an open composition with forms projecting into space, and the sense of a fleeting moment frozen in time—were intrinsic to the image of the rearing horse and made it an appealing subject for sculptors and their patrons. Works such as the Museum's *Rearing Horse*, which preserves its golden-red varnish, use this surface treatment to enhance the sense of movement as light shimmers across the animal's smooth, muscular body. The size of the horse, its dynamic pose with forelegs pawing the air, and the beauty of the patina all testify to De Vries's exceptional skill as a designer and maker of bronzes.

Born in The Hague, De Vries traveled to Florence in the early 1580s and joined the studio of Giambologna, the official sculptor to the Medici dukes. De Vries was Giambologna's most influential and innovative follower and played a key role in disseminating the Florentine Mannerist style of the late sixteenth century to the courts of Northern Europe. In 1601 De Vries was appointed official court sculptor to Rudolf II in Prague, where he continued to work until his death. Although he is known to have modeled sculptures in terracotta and stucco, De Vries worked primarily in bronze and became a superb technician, producing sculptures that were unusually consistent in their high level of accomplishment. In addition to his large-scale figures for complex fountain projects, De Vries executed numerous smaller bronzes for interior decoration, such as the *Rearing Horse*. De Vries produced several equestrian bronzes closely related to the Museum's composition, including a *Rearing Horse with Snake* in the Stockholm Nationalmuseum and a portrait of *Duke Heinrich Julius of Braunschweig on Horseback* formerly in the Herzog Anton Ulrich Museum in Brunswick. PAF

15 ADRIAEN DE VRIES
Dutch (active in Florence,
Milan, Augsburg, and Prague),
1545–1626
Juggling Man, circa 1615

Bronze
76.8 cm (30¼ in.)
90.SB.44

This muscular nude figure was inspired by a Hellenistic marble of a *Dancing Faun* in the Galleria degli Uffizi in Florence. The ancient, music-making *Faun* has horns and a small tail, holds cymbals, and steps on a foot organ. De Vries eliminated the horns and tail, changed the foot organ to bellows, and deleted the hand straps of the cymbals, transforming them into plates for juggling.

By consciously recalling an antique precedent, De Vries displayed his ability to rival the accomplishments of ancient artists. Moreover, his revisions to the composition demonstrated his powers of invention and his keen understanding of the human body in motion. Caught at a crucial moment in an acrobatic trick, with one plate perched precariously on his fingertips and the other seemingly suspended by centripetal force, the figure conveys extraordinary vitality and movement within a perfectly balanced composition. The vigorous treatment of the rippling muscles enhances the rhythm and elasticity of the open pose. The sculpture becomes a vehicle for the exploration of dynamic equilibrium. It may be relevant to note that feats of artistic virtuosity and juggling tricks shared a common term—*Kunststücke machen*—in sixteenth-century German usage. Such self-conscious demonstrations of artistic achievement were highly valued in the court of Emperor Rudolf II, for whom De Vries worked.

The expressionistic treatment of the anatomy, hair, and facial features in the *Juggling Man* recalls De Vries's other works from around the same date. The Museum's bronze is particularly close in scale and style to the *River Gods* and other figures from the *Neptune Fountain*, commissioned in 1615 for Frederiksborg Castle in Denmark (now at Drottningholm Castle, Sweden). However, the Museum's sculpture was most likely intended for display in an interior setting. Its dull discolored surface is the result of its placement outdoors in the twentieth century. PAF

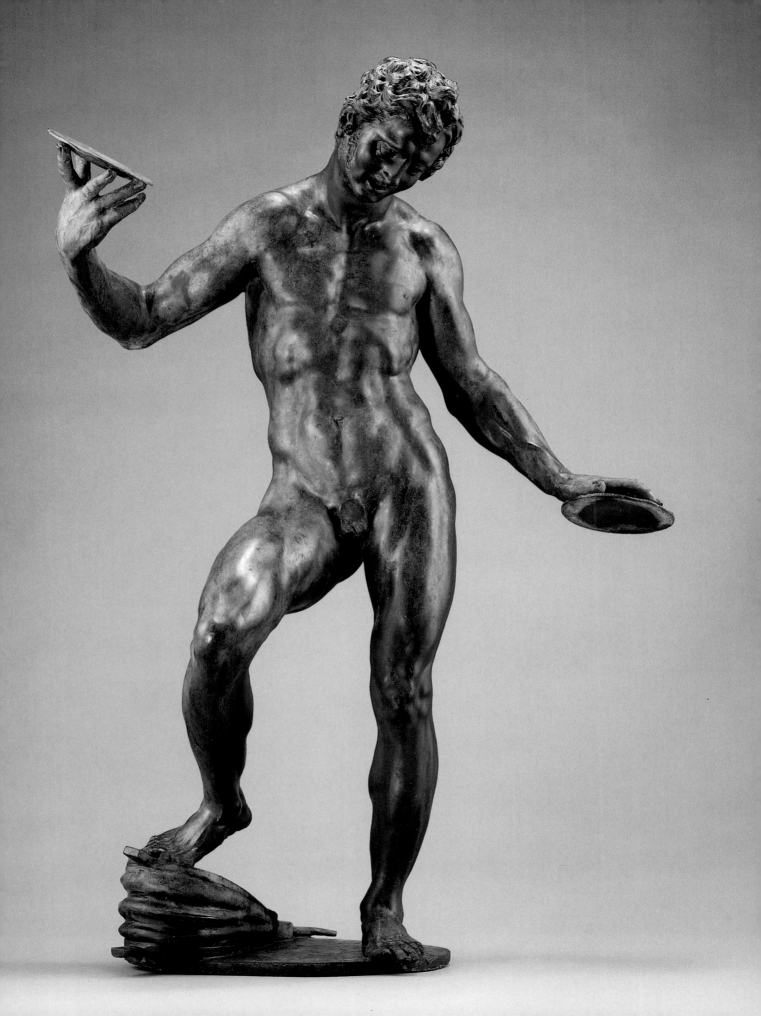

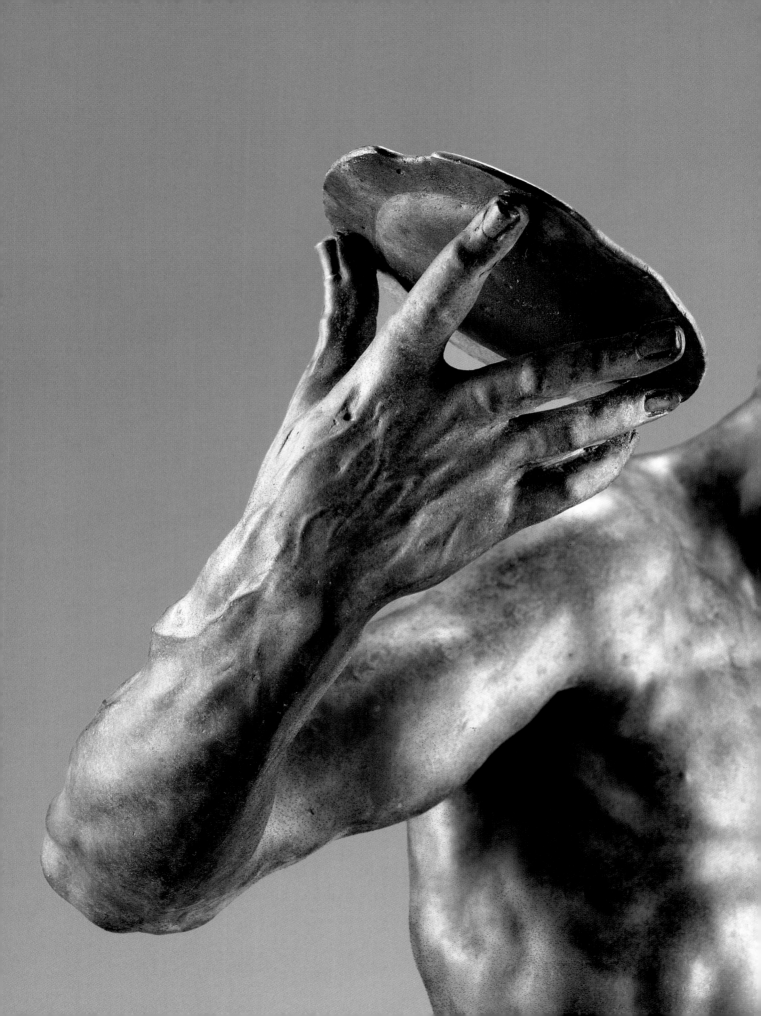

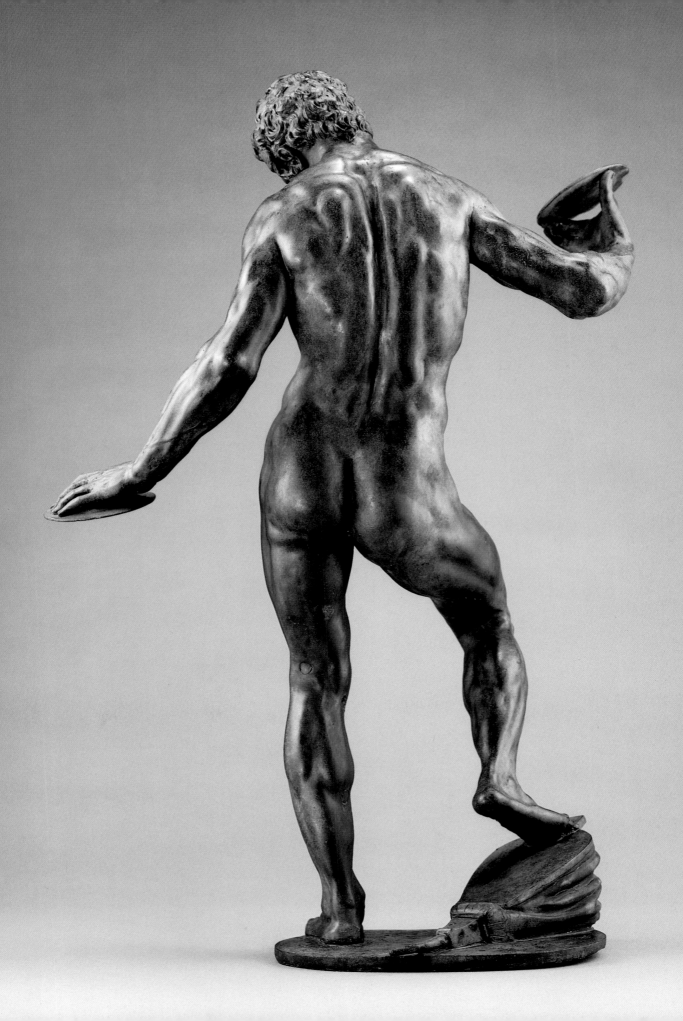

16 GIANLORENZO BERNINI
Italian (born in Naples,
active in Rome), 1598–1680
Boy with a Dragon,
circa 1614–1620

Marble
55.9 cm (22 in.)
87.SA.42

Gianlorenzo Bernini was the greatest innovator and most important proponent of the Baroque style in sculpture. His astonishing productivity, artistic scope, virtuosity, personal charisma, and recognition by contemporaries find their only parallels in the career of the Flemish painter Peter Paul Rubens. Bernini dominated the Roman artistic scene for approximately sixty years, receiving major sculptural and architectural commissions that transformed the face of the papal city. His influence was a predominant factor in the history of sculpture until the ascendancy of the Neoclassical style—in no small part a reaction against what Bernini had created—in the late eighteenth century.

Gianlorenzo began his training as an artist at a very young age under his father, Pietro, who was also a great sculptor. His early works demonstrate such technical competence and such a complete assimilation and understanding of earlier styles that he can truly be called a prodigy. Many of his early sculptures, including the Museum's *Boy with a Dragon*, display elements that would remain constant throughout his career: an interest in psychological realism; the acute rendering of emotional states; the depiction of movement, transience, and transformation in the intractable medium of marble; and the desire to establish interaction between the spectator and the work of art.

The subject of the Museum's *Boy with a Dragon* is rare in the history of sculpture. It was inspired by ancient Hellenistic marble sculptures depicting *The Infant Hercules Killing Snakes* and *A Boy Killing a Goose*. In seventeenth-century Italian inventories, the Museum's work was even incorrectly described as an *Ercoletto*, or young Hercules. In contrast to antique precedents, Bernini's sculpture possesses a playfulness and naturalism that seduce the spectator into the subject's world. Bernini's *Boy* still has rolls of baby fat and pudgy cheeks, wears a coy, mischievous smile, and looks out at the viewer rather that at his adversary, the dragon, whose jaws he seems to crack without any effort at all. Unlike antique marbles of *Hercules Killing a Dragon*, Bernini's *Boy* has the features of a Neapolitan street urchin (Bernini was born in Naples) rather than those of a mythological figure. Thus, Bernini has transformed a traditionally mythological subject with heroic implications into a genre-like scene, one that is more immediately accessible to the viewer and that extends the boundaries of what was previously considered serious art. PF

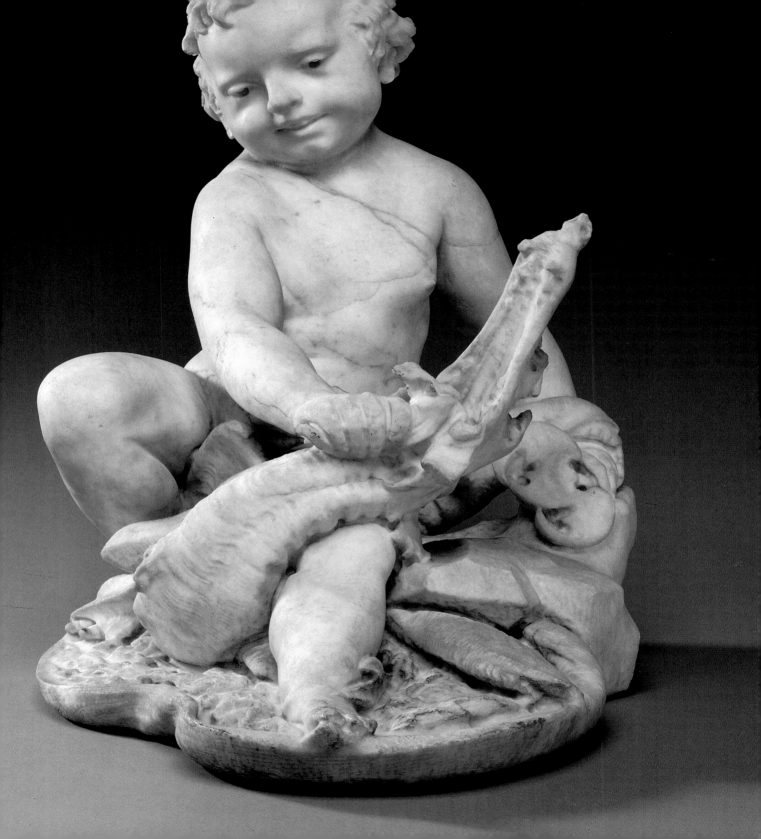

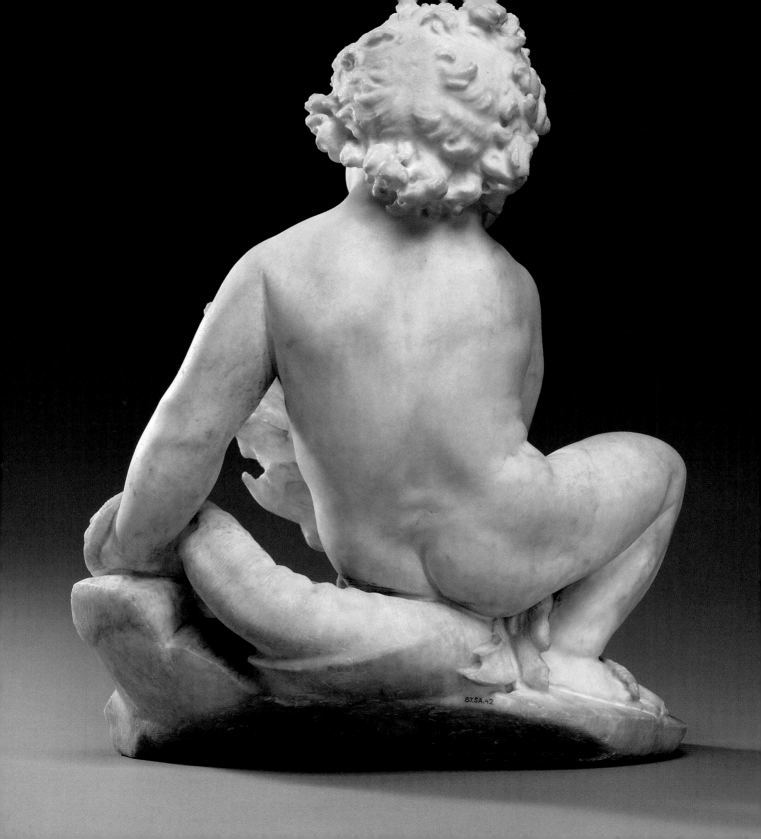

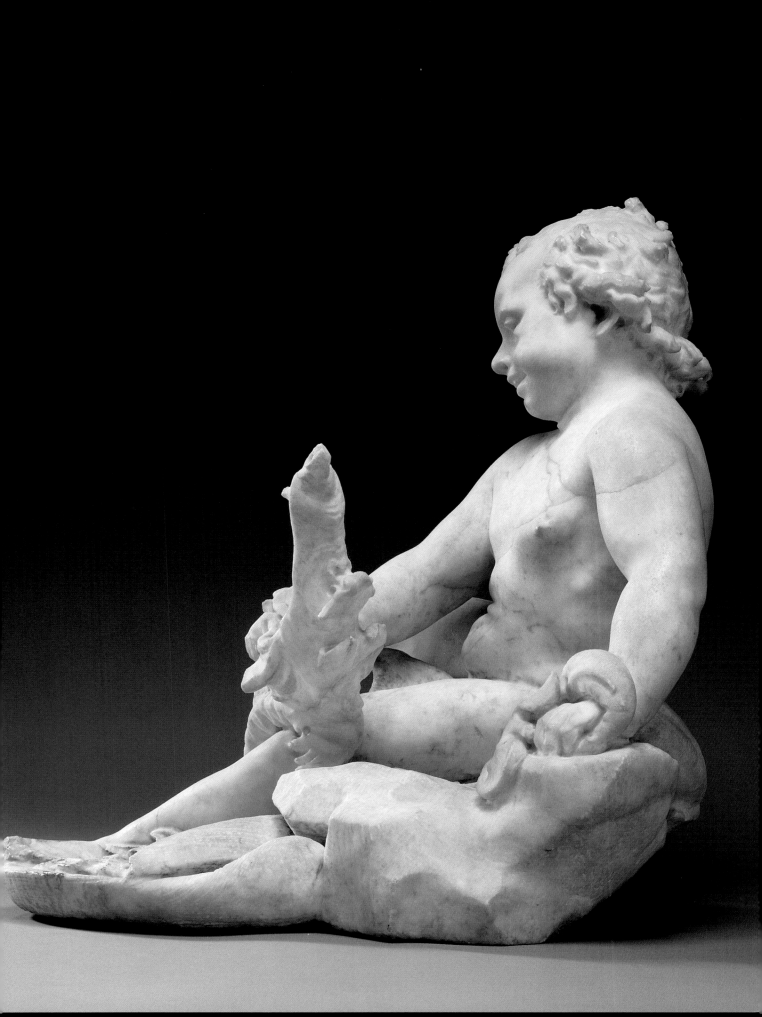

17 GIOVANNI FRANCESCO SUSINI
Italian (Florence),
circa 1585 – circa 1653
The Abduction of Helen by Paris,
1627

Bronze on an eighteenth-century
gilt-bronze socle
With base: 68 cm (26¾ in.)
Without base: 49.5 cm (19½ in.)
Inscribed: *IO.FR.SVSINI/FLOR.FAC./
MDCXXVII*
90.SB.32

This bronze depicts a cataclysmic event from Greek mythology as the Trojan prince Paris abducts Helen, wife of the Spartan king Menelaus, thus inciting the Trojan War. In Susini's portrayal, Paris, nude except for his cap, lifts the struggling figure of Helen as he steps over a fallen female figure who tries to stop them. The weight of Helen's voluptuous figure is convincingly suggested by the apparent slipping of her position against Paris's body and the strong, clutching grasp with which Paris holds her up. The precisely modeled, naturalistic details of the composition—apparent in Helen's facial features and flowing hair, as well as in the bulging veins in Paris's hands—further enhance the realism of the physical and emotional struggle. The bronze is cast with a rocky base suggestive of a landscape and is set into a later, gilt-bronze socle.

Giovanni Francesco Susini was a pivotal figure in Florentine sculpture of the early seventeenth century. While his *Abduction of Helen* still exhibits hallmarks of the late Mannerist style that dominated Florence, it nevertheless incorporates salient features of the new Baroque style being practiced in Rome. The central spiral motion of Paris's lithe body establishes a composition meant to be viewed from many angles, reflecting the influence of Florentine Mannerism. However, the selection of a primary view, the emphasis on psychological drama, and the sense of an instantaneous moment frozen in time are features associated with the Baroque. Specifically, Paris's striding pose, Helen's anguished, open-mouthed expression, and the treatment of the surface around Paris's fingers to convey a sense of Helen's soft, yielding flesh, all recall Gianlorenzo Bernini's marble *Rape of Proserpine*, which Susini would have seen on a trip to Rome in the early 1620s. Susini's extremely innovative group is one of the earliest manifestations of the Baroque style in Florentine sculpture.

PAF

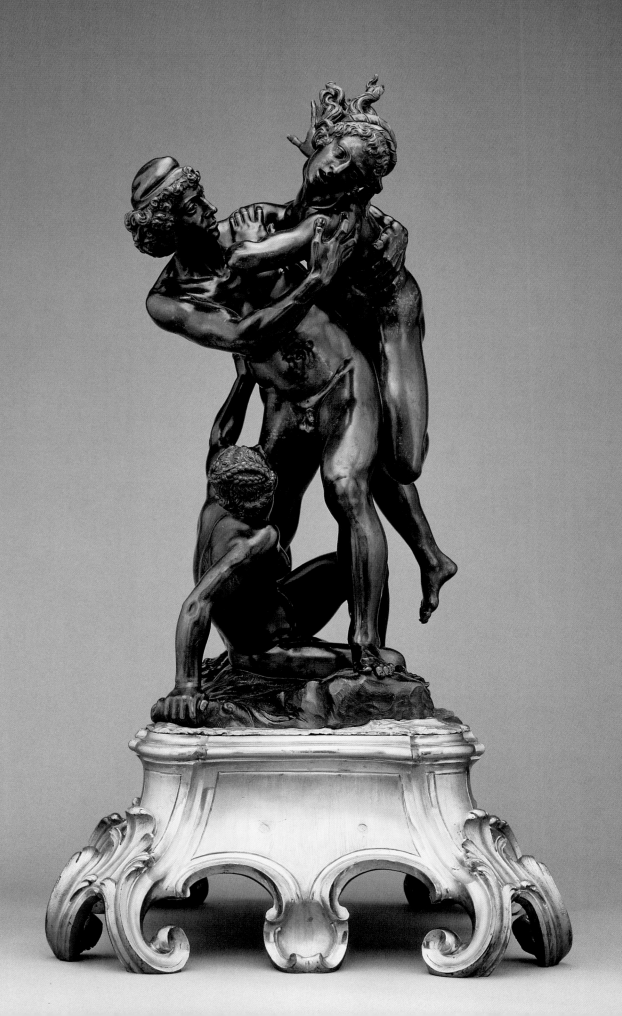

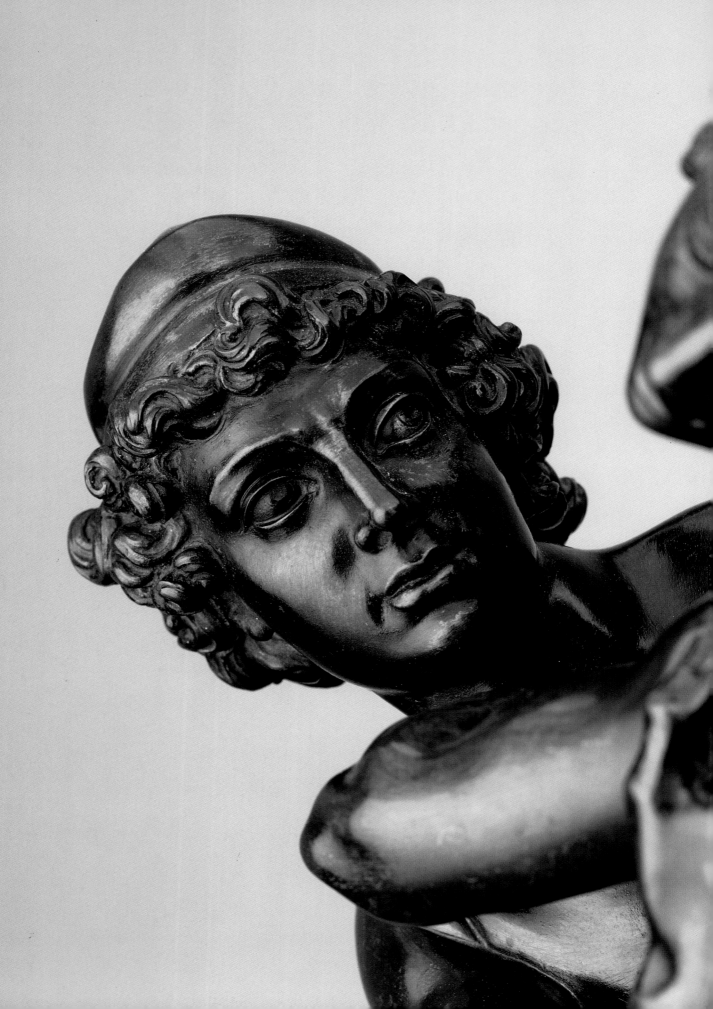

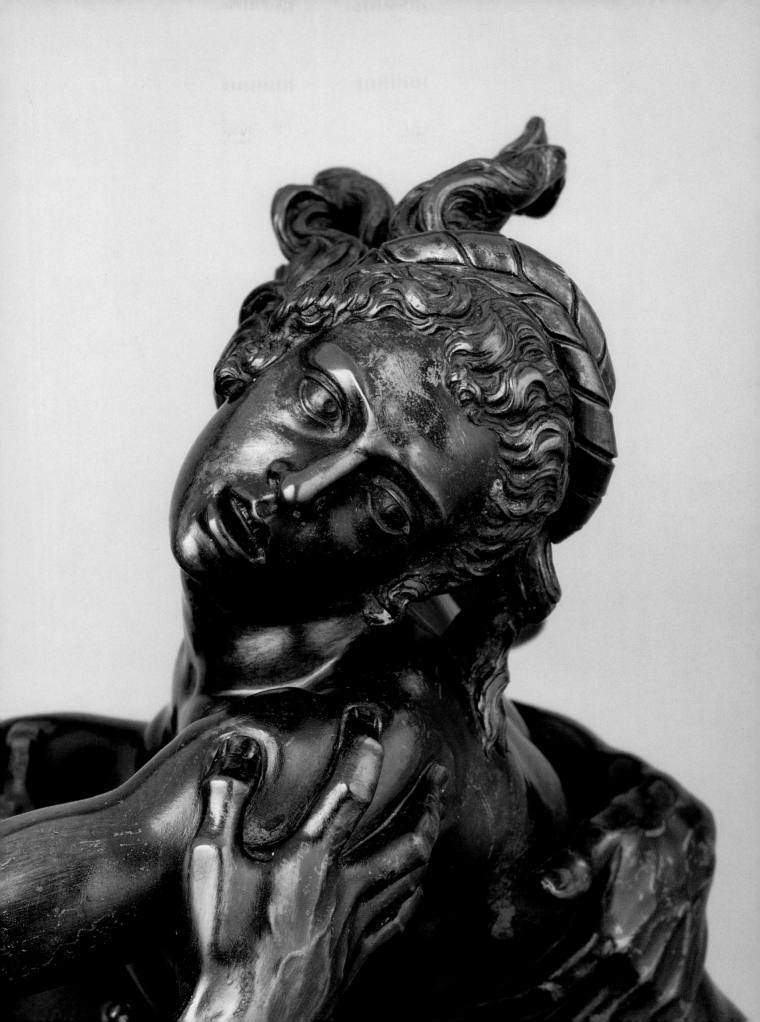

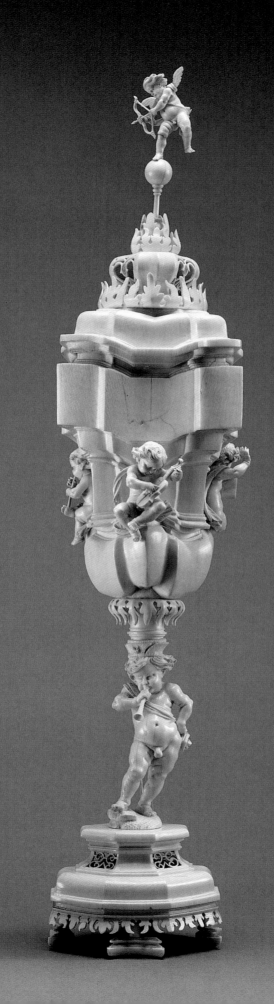

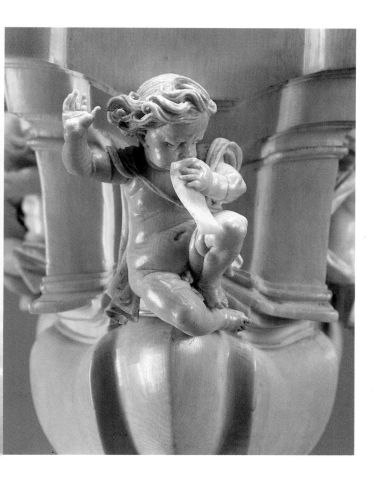

18 MARCUS HEIDEN
German (Coburg),
active by 1618–after 1664
Standing Covered Cup, 1631

Lathe-turned and carved ivory
63.5 cm (25 in.)
Inscribed under the base:
MARCUS.HEIDEN.COBURGENSIS.
FECIT.1631
91.DH.75

The art of turning ivory on a lathe to produce varying geometrical shapes was extremely popular in the Northern courts of Europe. Marcus Heiden, an ivory turner and master of fireworks and firearms at the court of Duke Johann Casimir in Coburg, was one of the greatest practitioners of this art in the Baroque period. The Museum's goblet, which was most likely made for Duke Johann, is composed of four main elements: an elongated octagonal base; a stem in the form of a trumpet-blowing infant; a geometrically conceived cup adorned with smaller, music-making infants; and a lid crowned by a cupid shooting an arrow. The pudgy, vigorously sculpted figures, whose anatomy reflects the influence of Peter Paul Rubens, may have been added to the cup sometime later in the seventeenth century.

The Museum's goblet exemplifies two major stylistic innovations in turned ivories that occurred during the first half of the seventeenth century. Earlier ivory standing cups had been characterized by their symmetrical disposition around a straight vertical axis and the prominence of abstract rather than figural elements. Heiden's goblet, however, incorporates both geometrical and figural forms. Furthermore, the standing, trumpeting infant who supports the body of the cup thrusts out his left hip, causing the vertical axis to shift asymmetrically and creating an illusion of movement. The playful poses of the infants seated around the cup enhance the sense of dynamic rotation, while the cupid perched on one foot atop a globe heightens the impression of precarious balance. The arrangement and carving of these figures make Heiden's goblet one of the earliest and most fully Baroque compositions in turned ivory.

PAF and PF

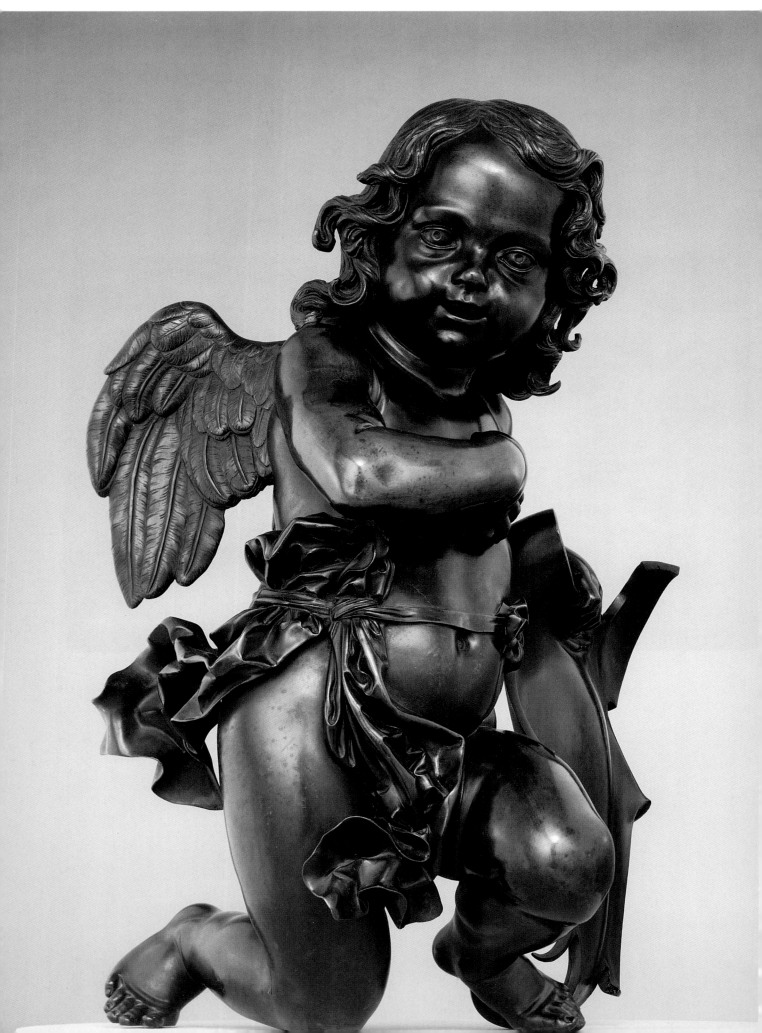

20 FERDINANDO TACCA
Italian (Florence), 1619–1686
*Putto Holding a Shield
to His Left*, 1650–1655

Bronze
65.1 cm (25⅝ in.)
85.SB.70.1

This figure is one of a pair of bronze putti, or naked winged infants, in the Museum's collection. The two sculptures, which mirror each other in pose, were commissioned to decorate the high altar of the Church of Santo Stefano al Ponte Vecchio in Florence. Renovations to the church were undertaken by the Bartolommei family, which employed Tacca to provide two bronze angels with inscribed cartouches to be placed above the altar. Although Tacca completed the project in 1655, it is not clear whether the angels ever reached their intended destination in the church. They may instead have been kept by the Bartolommei family for their own private collection, since the bronzes appear in inventories of the family palace in Florence as early as 1695.

Tacca inherited the studio and artistic legacy of Florence's greatest Mannerist sculptor, Giambologna. However, several features of the bronze *Putto* underscore Tacca's development away from the Mannerist style toward a more Baroque idiom: the realistic, pudgy anatomy; animated facial expression; theatrical gesture; and dynamic patterns of light created by the crinkled folds of drapery. Tacca's outstanding skill as a bronze caster is evident in the precise, masterful handling of details, as in the texture of the wing feathers and the curls of the hair. The *Putto* retains the translucent, reddish-brown lacquer patina typical of Florentine bronzes of this period.　　　　PAF

21 MICHEL ANGUIER
French (active in Rome and Paris), 1612–1686
Jupiter, probably cast toward the end of the seventeenth century from a model of 1652

Bronze
61 cm (24 in.)
94.SB.21

By the seventeenth century, two distinct iconographic traditions based on ancient precedents had been established for the depiction of the Roman god Jupiter. The first depicted the deity seated and enthroned as the supreme ruler of Olympus. The second, called in French *Jupiter tonnant* or *foudroyant* (thundering Jupiter), portrayed him standing as the god of Justice, presiding over the earth and meting out punishment with his fatal thunderbolts. Anguier's bronze statuette, which shows Jupiter stepping forward and raising a cluster of flaming thunderbolts in his right hand, clearly belongs to the second type of representation. Nevertheless, Jupiter's classical contrapposto stance and venerable countenance lend the image a sense of calm stability rather than one of violent or momentary action. The god's minutely defined, solid musculature and soft, clinging drapery enhance the impression of self-assured elegance that permeates the composition.

Anguier was one of the earliest proponents of a classicizing Baroque style in French sculpture of the seventeenth century. Around 1641 Anguier went to Rome, where he lived for the next ten years, joining the workshop of one of the city's leading sculptors, Alessandro Algardi. While in Italy, Anguier devoted himself to the study of ancient art and literature. In fact, the pose and physiognomy of the Museum's *Jupiter* were inspired by an antique marble that Anguier would have seen in the Palazzo Giustiniani in Rome. In 1652, shortly after his return to Paris, Anguier modeled a series of seven figures representing gods and goddesses according to their temperaments: thundering Jupiter, jealous Juno, agitated Neptune, tranquil Amphitrite, melancholy Pluto, Mars abandoning his weapons, and distraught Ceres. Although there are several bronze examples in existence for five of the deities, the Museum's statuette is the only known cast of Anguier's *Jupiter*. It exhibits features typical of the sculptor's male figures, including highly articulated musculature; wavy clumps of hair; protruding veins in the arms and feet; and a prominent, aquiline nose. PAF

22 ROMBOUT VERHULST
Flemish (active in Amsterdam,
Leiden, and The Hague),
1624–1698
Bust of Jacob van Reygersberg,
1671

Marble
62.9 cm (24¾ in.)
Inscribed on the front: *MEA SORTE
CONTENTUS;* inscribed on the
proper left: *R. Verhulst fec.;* inscribed
on the proper right: *Anno 1671;*
inscribed on the back: *DIT IS HET
AFBEELTSEL VAN IACOB VAN
REIGERSBERGH, GEBOREN IN
MIDDELBURGH DEN.X.APRIL.
1625. WEGENS DE PROVINTIE
VAN ZEELANT GEDEPUTEERDT
TER VERGADERINGH VAN HAER
HOOGH MOGENTHEDEN DEN.
17.7BER DES IAERS 1663 STURF
DEN .29.APRIL.1675*
84.SA.743

Rombout Verhulst was a brilliant portraitist and the foremost Flemish marble carver of the seventeenth century. Born in Mechelen, Verhulst moved to Amsterdam in 1646 and worked with the leading sculptor Artus Quellinus on the decoration of the new town hall. After Quellinus left for Antwerp in 1665, Verhulst became the most prominent Baroque sculptor in the Netherlands. His oeuvre consists primarily of tomb monuments, portraits, and garden sculpture, although he also produced small works in ivory. The Museum's bust exemplifies Verhulst's realistic portrait style in its subtle modeling of facial features and rich differentiation of textures in the hair, armor, and lace jabot. In this sculpture, Verhulst also employed a unique and inventive formal solution to mitigate the truncation at the shoulders and chest: he used decorative, curving volutes and foliage at each side and below the armor to frame the bust and lead the viewer's eye up toward the face.

Jacob van Reygersberg (1625–1675) was a representative for the province of Zeeland at the States General of the Netherlands and a director of the Admiralty, as well as the owner of Couwerve and Crabbedijke Manors and Westhove Castle. As such, he carried the title of Lord of Couwerve and Crabbedijke. When Verhulst executed this portrait bust in 1671, Van Reygersberg was forty-six years old and at the height of his political career. Independent marble busts of this period were rare and were generally commissioned by members of the Amsterdam regents or of the court circles at The Hague. Despite Van Reygersberg's official status and wealth, he did not belong to these institutions and therefore may have commissioned the portrait with the intention of later incorporating it into a tomb monument. At any rate, Van Reygersberg died four years after the bust's completion, and a commemorative inscription and motto were then added, giving the sculpture definite funereal overtones and lending it the quality of a cenotaph. The Latin device carved on the front of the socle below the scrolling ornament reads "I am content with my lot," implying Van Reygersberg's acceptance of death. The inscription on the back of the bust identifies him in the following terms: "This is the image of Jacob van Reygersberg, born in Middelburg on April 10, 1625. Representative for the province of Zeeland at the assembly of the High and Mighty [States General] on September 17, 1663[.] Died on April 29, 1675." PAF

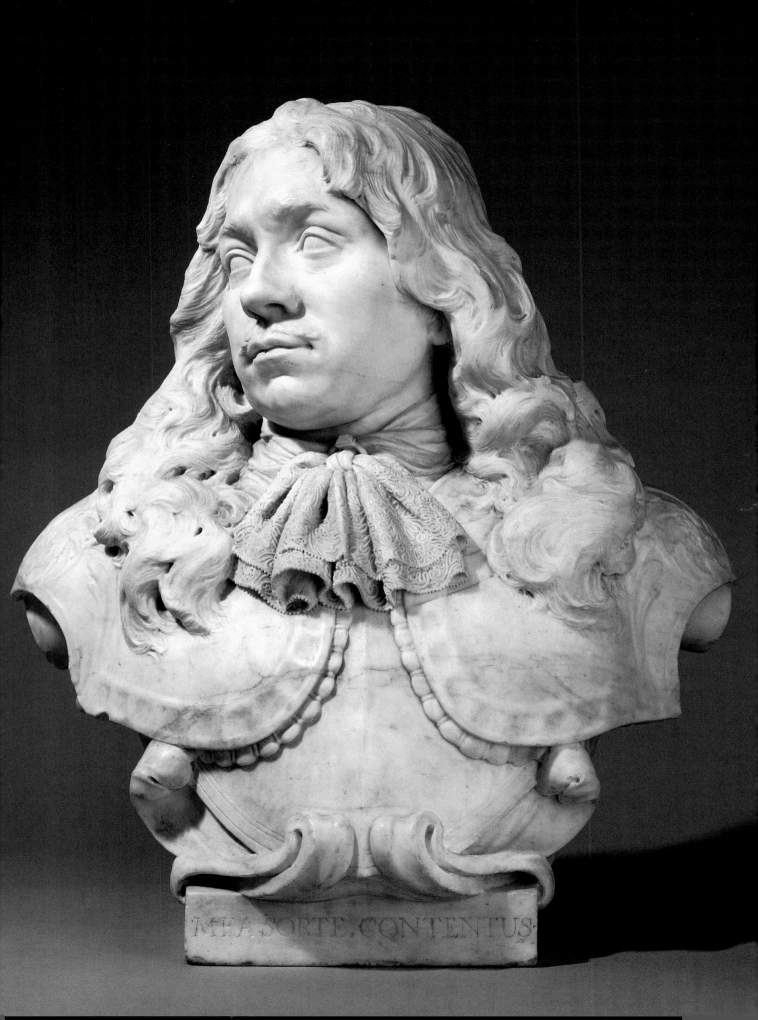

MEA SORTE CONTENTUS

23 *Corpus*
Flemish, circa 1680–1720

Boxwood
48.3 cm (19 in.)
82.SD.138.1

This elegant depiction of the crucified Christ is unusual in its gentle sensuality and avoidance of details suggestive of Christ's physical suffering. The crown of thorns, the lance wound to the side, and any indication of blood dripping from the nail holes are all absent from this portrayal. Christ's musculature is smooth and strong, showing no signs of emaciation. His torso forms a sinuous curve, with one hip raised. The loincloth, which falls in directional folds that echo the sway of his body, is held in place by a double rope forming decorative semicircles at his hips. His robust and fluidly modeled arms are relatively horizontal, defying the weight of his lifeless body, or corpus; his figure would seem to float in front of the cross rather than hang from it. Christ's serene face, with gently closed eyes and mouth, and unwrinkled brow, registers no sign of agony.

The sculptor of the Museum's *Corpus* has ingeniously combined the traditional iconography of *Cristo morto*, the dead Christ on the cross, with that of *Cristo vivo*, Christ alive on the cross. Before the tenth century, Crucifixion scenes commonly portrayed Christ on the cross with his arms held out horizontally and his facial expression alert and triumphant, as victor over sin. Later, Christ was more often depicted dead on the cross, his arms stretched vertically and pulled by the weight of his limp body, his torso emaciated and bearing the wounds of his torture and suffering. By the sixteenth century, the two iconographies existed concurrently. The diffusion of both types in Flemish sculpture was highly influenced by the painted compositions of Peter Paul Rubens. Rubens's importance for the Museum's *Corpus* is apparent in the positioning of the head and the physiognomy and expression of the face.

PAF

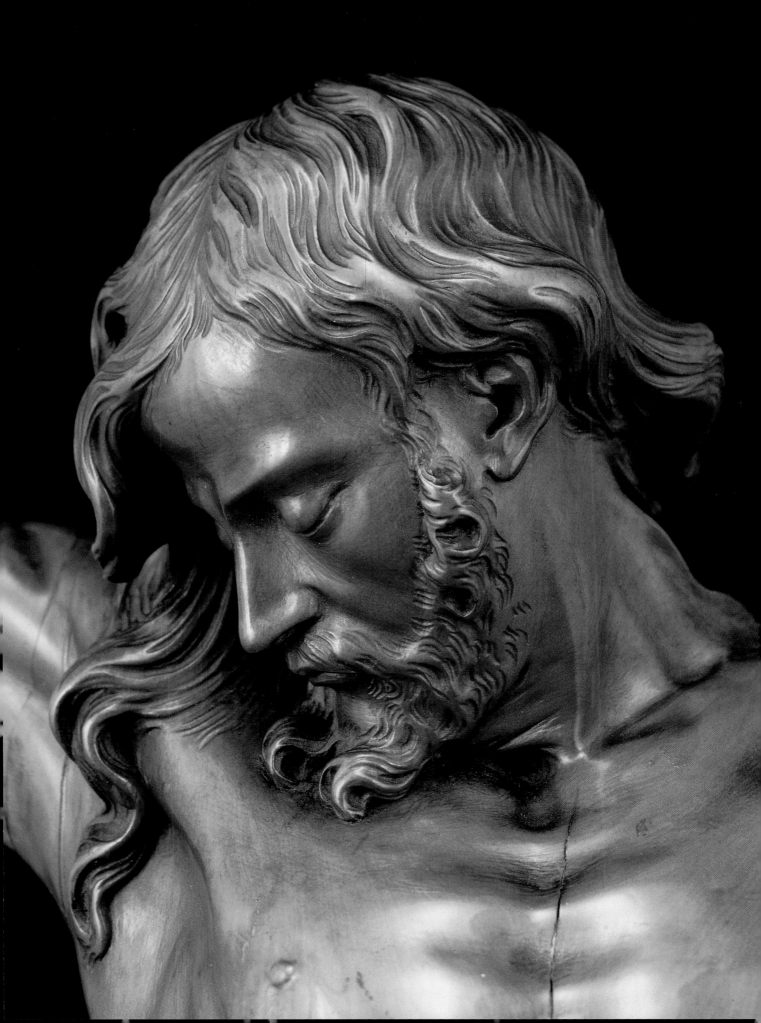

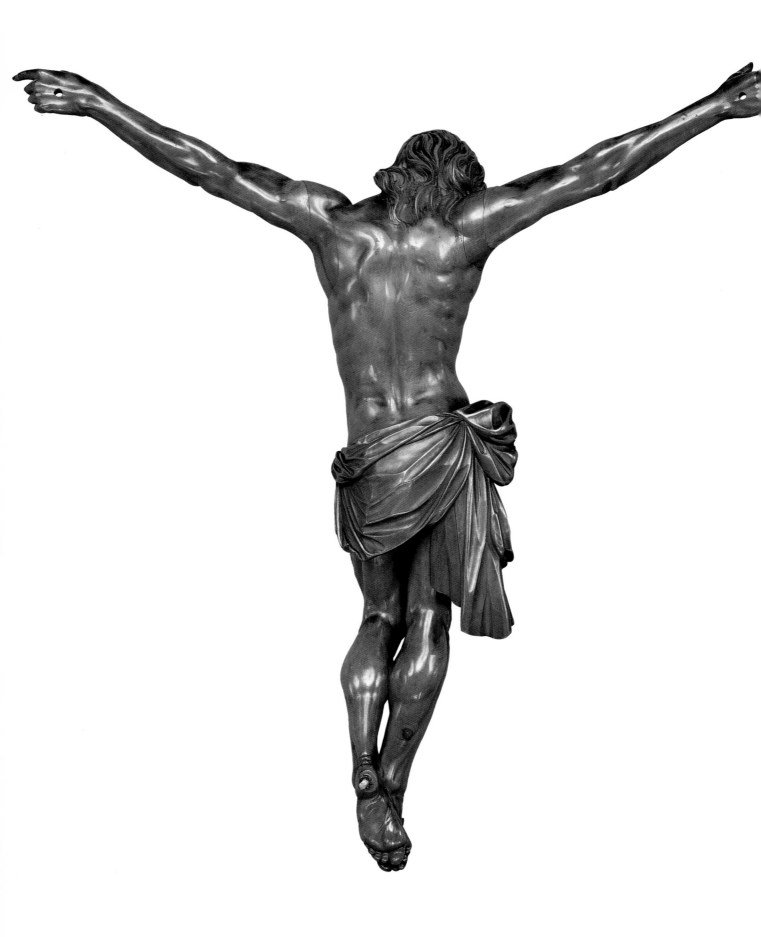

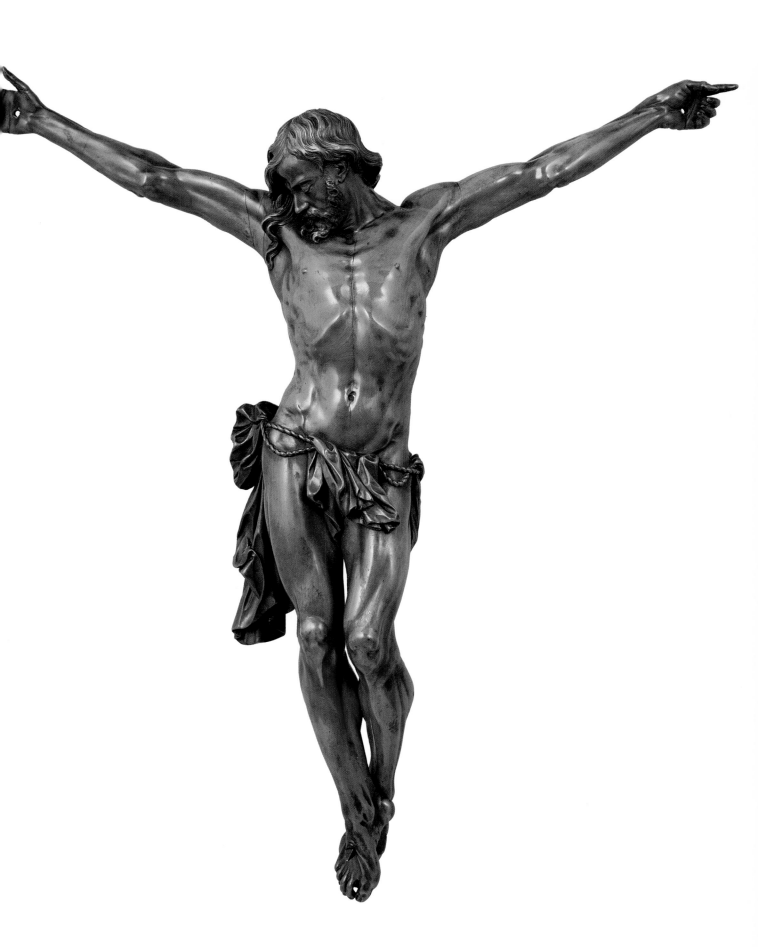

24 CHRISTOPH DANIEL SCHENCK

German (Konstanz), 1633–1691
The Penitent Saint Peter, 1685

Limewood
36.5 x 26.7 cm (14⅜ x 10½ in.)
Inscribed at lower right: *C.D.S. 1685*
96.SD.4.2

This relief illustrates the biblical account of Saint Peter's lamentation: "And Peter remembered the word of Jesus, which said unto him, Before the cock crow, thou shalt deny me thrice. And he went out, and wept bitterly" (Matthew 26:75). The figure of Saint Peter dominates the panel and displays a sense of monumentality and three-dimensionality unusual in relief sculpture. Schenck achieved this by cutting deeply into the wood, so that the grief-stricken expression of the deeply lined face, the hands clasped in a gesture of lamentation, and the gnarled feet that press into the lower ledge of the panel make a particularly strong visual impact. The swirling, circular forms of the drapery further emphasize the implied volume of the figure and create a sense of motion and emotion that make for a powerful and sensitive depiction of the story.

In the background, scenes recounting the events that led to Saint Peter's lamentation appear in low relief. In the lower right, Saint Peter denies Christ for the third time, which he acknowledges by holding up three fingers. Above this scene, in the upper right, the cock crows, with wings spread and mouth open, fulfilling Christ's prediction. At the upper left, Christ is led away by cruel, mocking soldiers, adding to the bitterness of Peter's grief, since this occurred at the same time that Peter denied him. While presenting an image of deep human despair, this relief would have offered hope to its viewers, providing reassurance that even Saint Peter, Prince of the Apostles, sinned, repented, and was forgiven.

Schenck, working in the area of southern Germany and northern Switzerland around Lake Konstanz, frequently treated religious themes of penitence and suffering, often for monastic patrons. Though he was firmly grounded in the traditions of Northern prints and wood sculpture—evident in the starkly expressive naturalism of this relief—Schenck was also aware of Italian Baroque models, made clear here by Saint Peter's monumentality and the animated drapery. MC

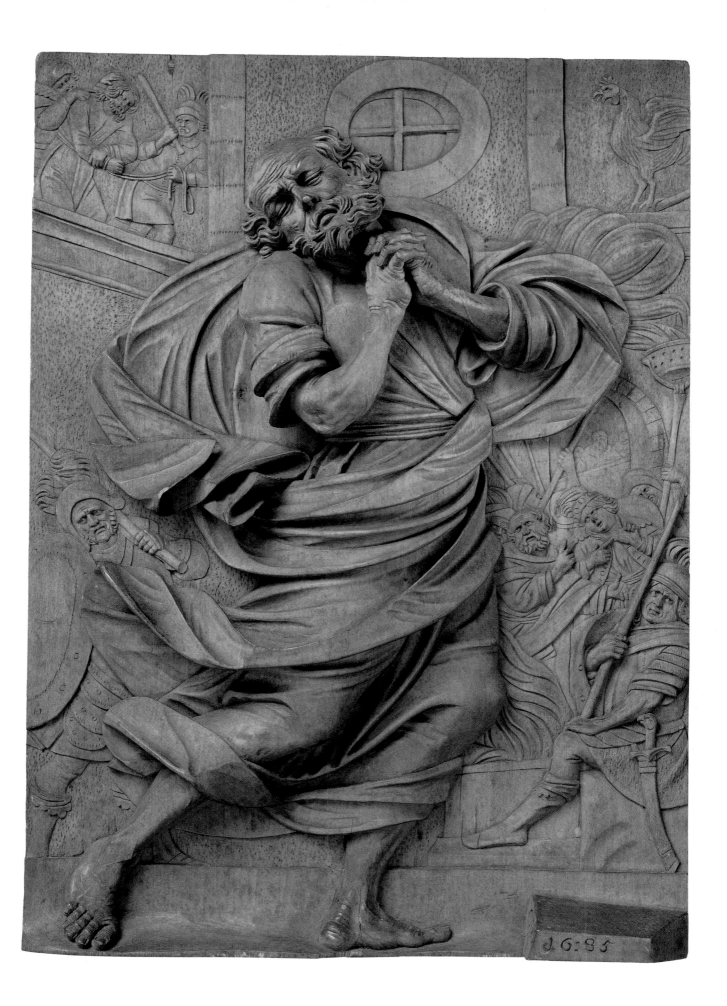

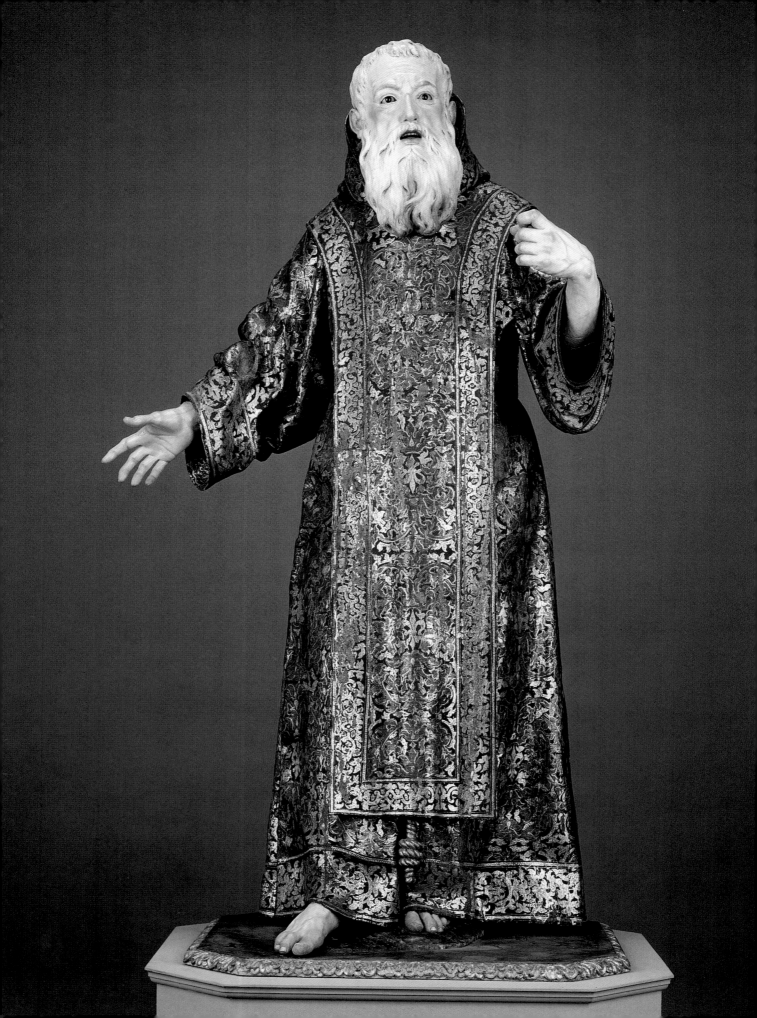

25 LUISA ROLDÁN
called La Roldana
Spanish (Madrid),
1652–1706
Saint Ginés de la Jara, 169(2?)

Polychromed wood (pine and cedar)
with glass eyes
175.9 cm (69¼ in.)
Inscribed on the top of the base:
[LUIS] *A RO*[LD] *AN,*
ESC [U] *L* [TO] *RA DE CAMARA*
AÑO 169 [2?]; also inscribed
several times on the robe:
S. GINES DE LAXARA
85.SD.161

This statue challenges the boundaries between art and reality. Life-sized, carved and painted to resemble a living human being, and dressed in a brocaded robe made of wood that seems to have the qualities of fabric, this startling image displays the verisimilitude characteristic of Spanish Baroque sculpture. The immediacy of the image would have intensified the devotional experience of the viewer by making the holy figure seem real and present. The effect is heightened by the actions and expression of the saint, who walks forward, looking intently to his left. His mouth is open as if he were speaking, his right hand is extended in wonder, and he probably held a staff in his left hand.

Various legends describe how Saint Ginés, who was descended from French royalty (explaining the use of the fleur-de-lys, emblem of the kings of France, in the pattern of the robe), came to be venerated in the area of Murcia, Spain, known as La Jara. One tells how the saint, washed ashore in a shipwreck as he made a pilgrimage to Santiago de Compostela, took up the life of a hermit on the site, which, in the fifteenth century, became the Franciscan Monastery of La Jara, dedicated to him. Another recounts that, after being beheaded, the saint threw his own head into a river; the severed head washed up at La Jara, which became the center of his cult.

Luisa Roldán, one of the few known female sculptors of the seventeenth century, learned her craft from her father, the sculptor Pedro Roldán of Seville. She produced small terracotta groups as well as wood sculptures in collaboration with her husband, who was responsible for the polychromy and *estofado*. This technique is brilliantly exemplified in the robe of *Saint Ginés*, where gold leaf was applied to the wood and covered with brown pigment; the pigment was then scratched away to reveal the gilding, simulating a brocade pattern, and further enriched by the use of punchwork on the gold surfaces. La Roldana's success culminated in her appointment as sculptor to the royal court (*Escultora de Camara*) by Charles II in 1692; she signed the *Saint Ginés* with her name and royal title.

MC

26 FRANÇOIS GIRARDON
French (Paris), 1628–1715
Pluto Abducting Proserpine,
cast circa 1693–1710

Bronze
105.1 cm (41⅜ in.)
Inscribed on the top of the base:
F. Girardon Inv. et F.
88.SB.73

Girardon was the pre-eminent sculptor to Louis XIV, working on royal projects at the châteaux of Versailles and Marly, as well as in Paris. His early training was completed by a stay in Italy, where Girardon's study of ancient and modern sculpture formed the basis for his refined, classicizing style. After his return to France in 1650, Girardon was supported by Charles Le Brun, First Painter to the King. The commission in 1666 for a major marble group of *Apollo Served by the Nymphs* for the Grotto of Thetis at Versailles marked Girardon's success at court, and his steady progress through the ranks of the Académie Royale de Peinture et de Sculpture culminated in his appointment as *Chancelier* in 1695.

This bronze was based on Girardon's monumental marble sculpture, one of four three-figured abduction groups that were part of a grandiose sculptural program for the Parterre d'Eau at Versailles. These groups, each commissioned from a different sculptor, were to symbolize the Four Elements in a larger cosmic scheme revolving around the association of Louis XIV with the sun god, Apollo. Girardon's group, alluding to the element of Fire, represents Proserpine being kidnapped by the god of the underworld, Pluto, who made her queen of his fiery kingdom. Pluto lifts Proserpine from the ground and strides over the recumbent body of one of her companions, the nymph Cyane, who grasps a bit of drapery in a futile attempt to prevent the abduction.

In his conception of the struggling group, Girardon demonstrated his study of Giambologna's famous three-figured abduction group, *The Rape of a Sabine* (1581–1582), and created a complex composition that presents a variety of satisfying and informative views. Girardon also relied on Gianlorenzo Bernini's two-figured, dramatic version of the story of Pluto and Proserpine, in which the violence of the event is conveyed through extreme action, gesture, and facial expression. Girardon reduced the qualities of motion and emotion found in Bernini's group and presented a more noble, restrained image of the theme, consonant both with the decorum characteristic of French classicism and with the requirements of the original commission for a sculpture representing one Element in a cosmic scheme.

Girardon produced several bronze versions of this popular composition, which were sometimes paired with another group from the Parterre d'Eau, Gaspard Marsy's *Boreas Abducting Orithyia*. The J. Paul Getty Museum acquired the Girardon sculpture with a pendant version of the Marsy group.
 MC and PAF

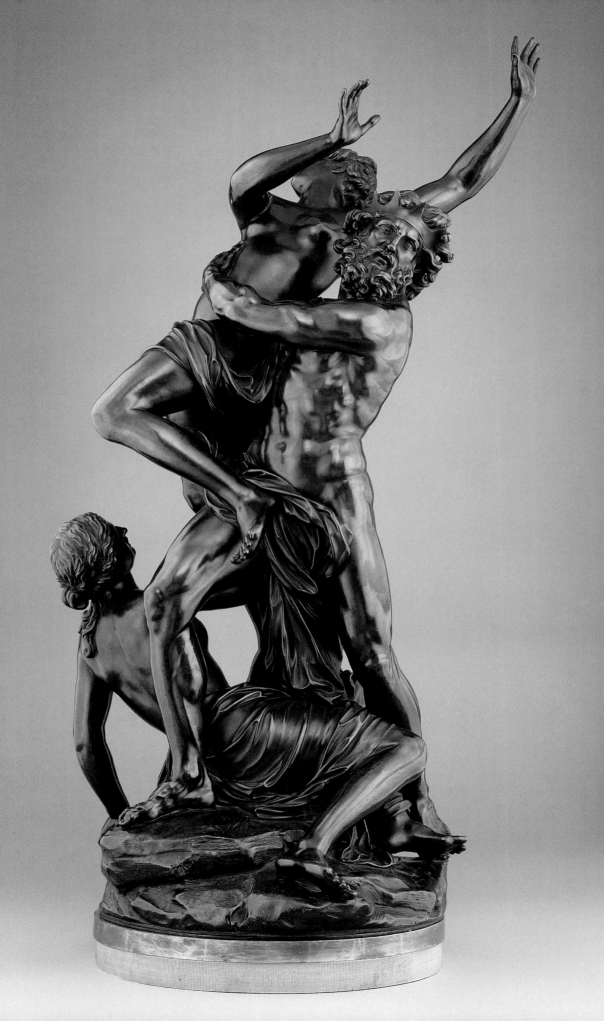

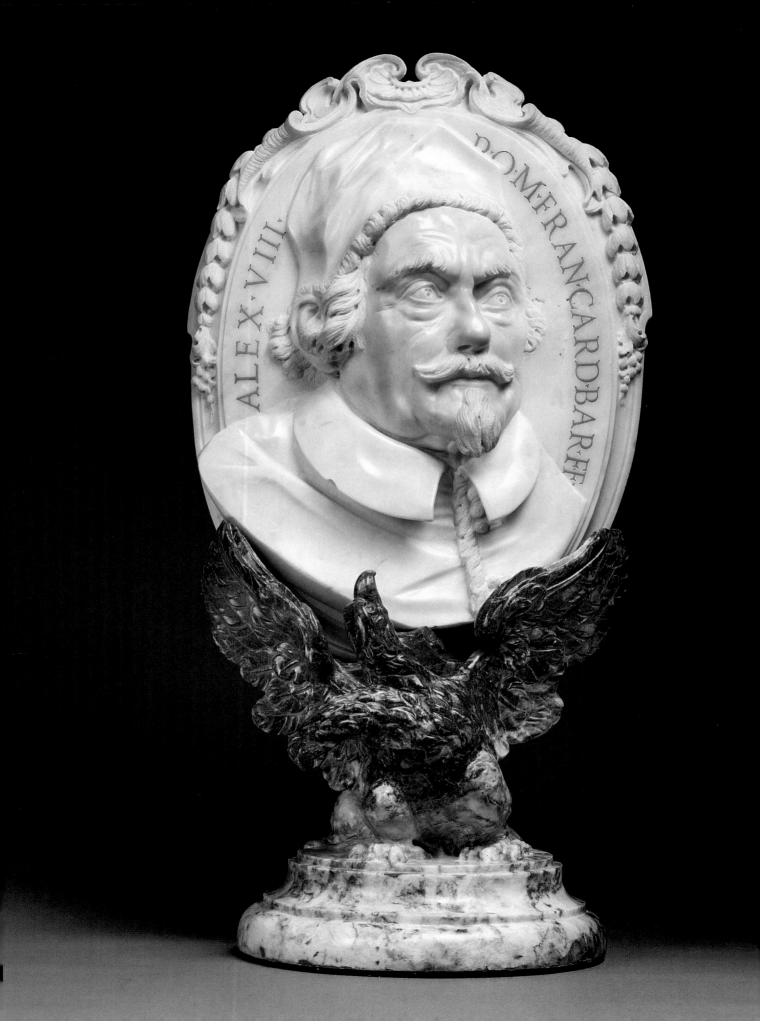

27 LORENZO OTTONI
Italian (Rome), 1648–1726
Portrait Medallion of Pope Alexander VIII, 1691–1700

White marble medallion mounted
on a *bigio antico* marble socle
With socle: 88.9 cm (35 in.)
Inscribed around medallion: *ALEX.
VIII.P.O.M.FRAN.CARD.BARB.F.F*
95.SA.9.1–.2

This portrait medallion represents Pope Alexander VIII Ottoboni, who reigned briefly from October 6, 1689, to February 1, 1691. The inscription, which reads in English "Alexander VIII Pontifex Optimus Maximus Cardinal Francesco Barberini had it made," identifies both the sitter and, unusually, the patron of the work, establishing a close relationship between them. A member of a noble Venetian family, Alexander VIII was popular for reducing taxes, increasing inexpensive food imports, alleviating political tensions with France, and supporting Venice in its war with the Turks. He was vigilantly opposed to Jansenist and other reform movements. Cardinal Francesco Barberini *Giuniore* commissioned this image to commemorate the pope, who had elevated him to the cardinalate in 1690. Alexander VIII is shown wearing the *camauro*, an ermine-trimmed cap, and *mozzetta*, or humeral cape, non-liturgical vestments for informal audiences.

The portrait medallion is set on to a *bigio antico* socle carved in the form of a double-headed eagle that seems to hold the image aloft. Rudolf II granted the Ottoboni family permission to add this imperial device to their arms in 1588, in recognition of their assistance in fighting the Turks. The sculptor, Lorenzo Ottoni, took advantage of the natural shading of the gray marble by carving the eagle from the darkest part of the stone, which effectively sets off the bright white marble of the medallion. Ottoni, a member of the circle of the Barberini family in late seventeenth-century Rome, also carved a series of portrait busts of Barberini family members, including one of Cardinal Francesco's father.

This work combines several elements usually found in commemorative monuments or tomb sculpture, making it a small but densely symbolic memorial image of the pope, created in the decade after his death. For example, portrait medallions were often employed as part of architectural tomb structures. Furthermore, the eagle—a reference to the Ottoboni coat of arms and thus a heraldic, dynastic motif—seems to carry the image and, conceptually, the sitter heavenward. MC and PF

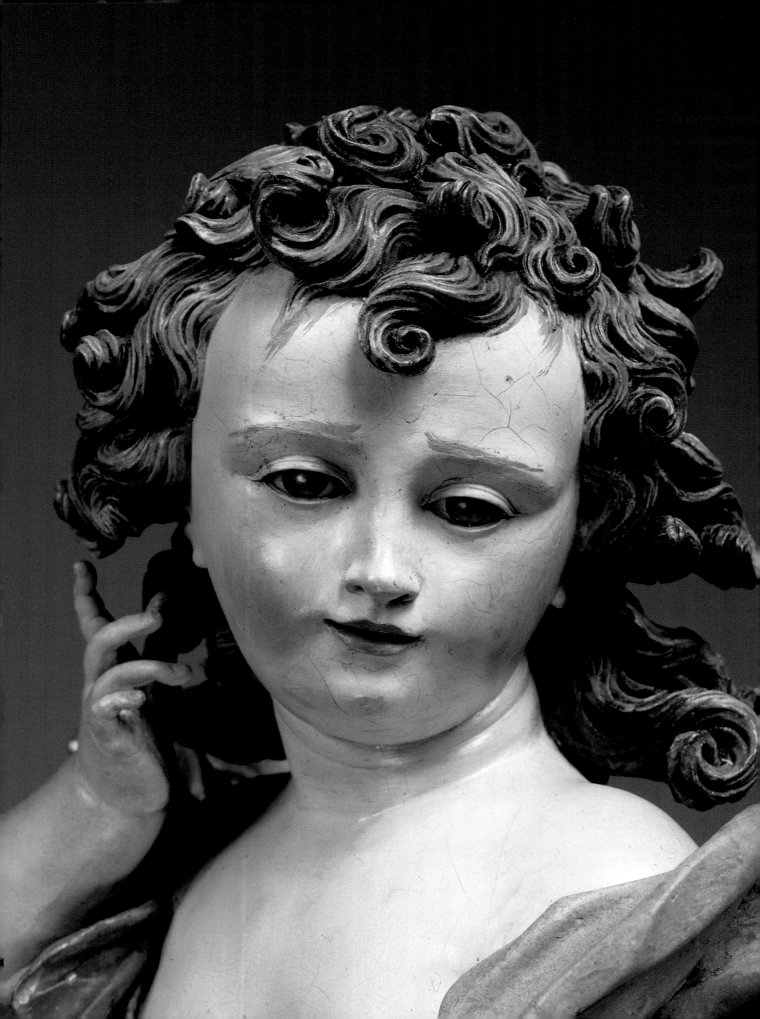

28 Attributed to ANTON
MARIA MARAGLIANO
Italian (Genoa), 1664–1739
Christ Child, circa 1700

Polychromed wood with glass eyes
73.7 cm (29 in.)
96.SD.18

This sculpture represents the Christ Child, standing on a base that suggests a rocky landscape, and nude but for the windblown cloak that wraps around his arms and trails behind his left leg. His upper torso and shoulders twist toward his left as he extends his left hand, probably to display an object now lost. This may have been a globe, which would have conveyed the idea of Christ as *Salvator Mundi* (Savior of the World), or, perhaps, a bunch of grapes, which would have stressed a Eucharistic theme. His right hand is bent inward with a delicate gesture which suggests that the *Christ Child* is listening to the prayers of the viewers. Carved completely in the round and meant to be seen from all sides and from below, the statue may have been carried in processions, a popular form of devotional expression in seventeenth-century Italy.

The attribution to Maragliano is based on a comparison with his known works, many produced for confraternities in Genoa, where the tradition of processional wood sculpture was very strong. Maragliano's sculptures share with the *Christ Child* a vivid, animated quality; the naturalism and direct emotional appeal characteristic of polychromed wood sculpture; spiraling curls of hair; and fluttering drapery that imparts a typically Baroque dynamism. This *Christ Child* is particularly charming, given the fleshy forms of the child's anatomy, such as the chubby ankles and knees and the rounded belly, the sweetness of his expression, and the delicacy of his gestures, which also serve to integrate the figure into the visual culture of Genoa in the years around 1700.

MC

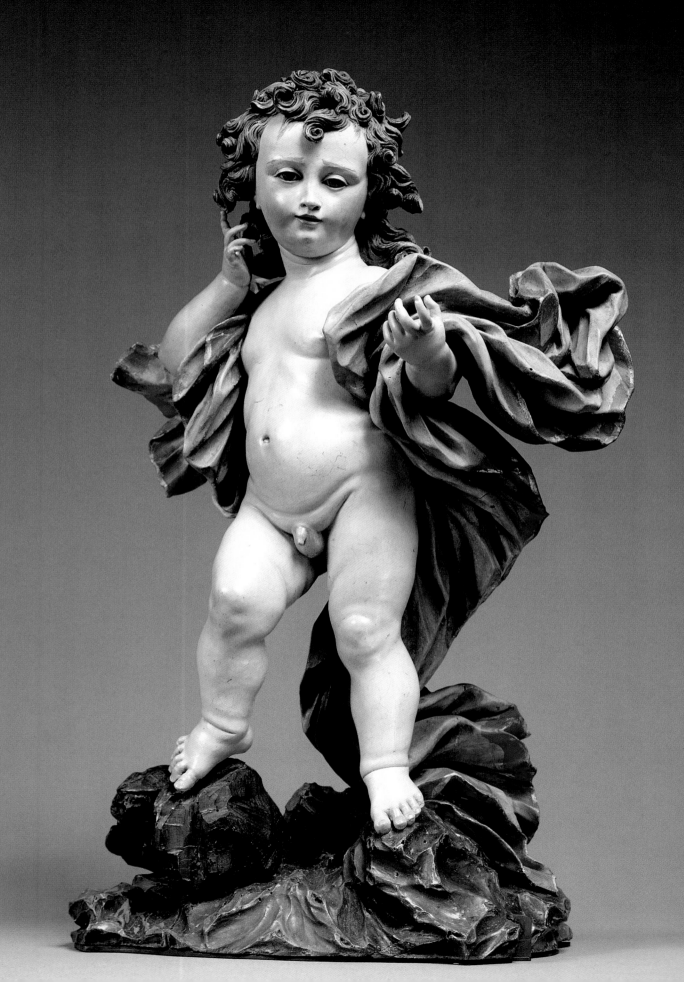

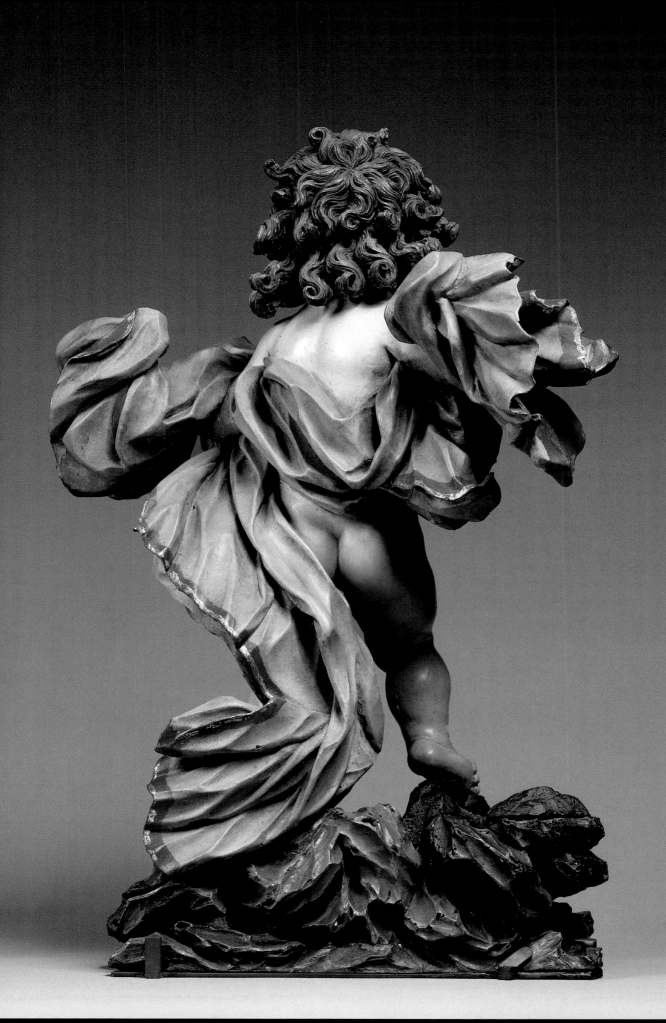

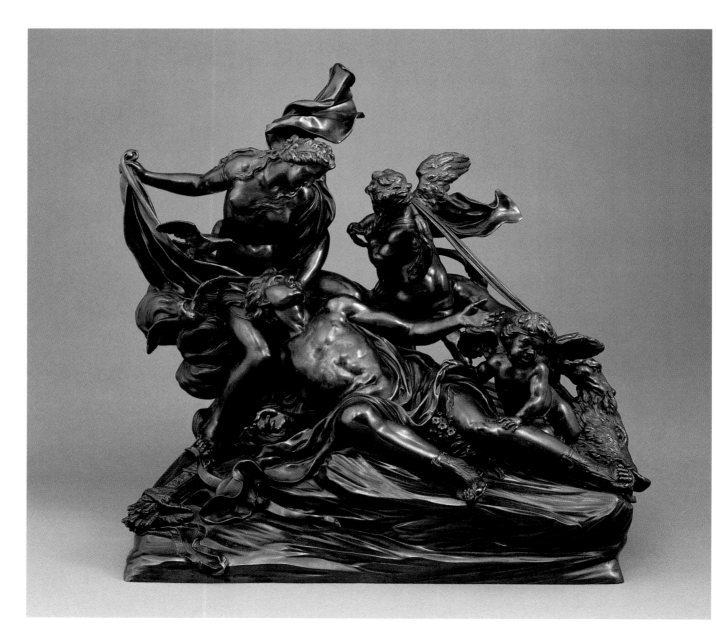

29 MASSIMILIANO SOLDANI BENZI, called Soldani
Italian (Florence), 1656–1740
Venus and Adonis,
circa 1715–1716

Bronze
46.4 cm (18¼ in.)
93.SB.4

Soldani was arguably the finest bronze caster in late seventeenth- and early eighteenth-century Europe. He was also, along with Giovanni Battista Foggini, the most significant proponent of the Florentine late Baroque style in sculpture.

The Museum's group depicts the story, drawn from Ovid's *Metamorphoses* (10.495–739), of the death of Adonis. Typical of Soldani's theatrical style, the figures are composed as if on a stage with a primary frontal view, calling to mind productions of opera—a genre that had been invented in Florence a century earlier. The scenographic quality in the group is enhanced by the inclusion of landscape details, such as the rocky ground, flowers, and clouds, which serve as props for the unfolding narrative. The group depicts a climactic moment and emphasizes the poignant tragedy of the lovers—the wounded and dying Adonis lies on the ground,

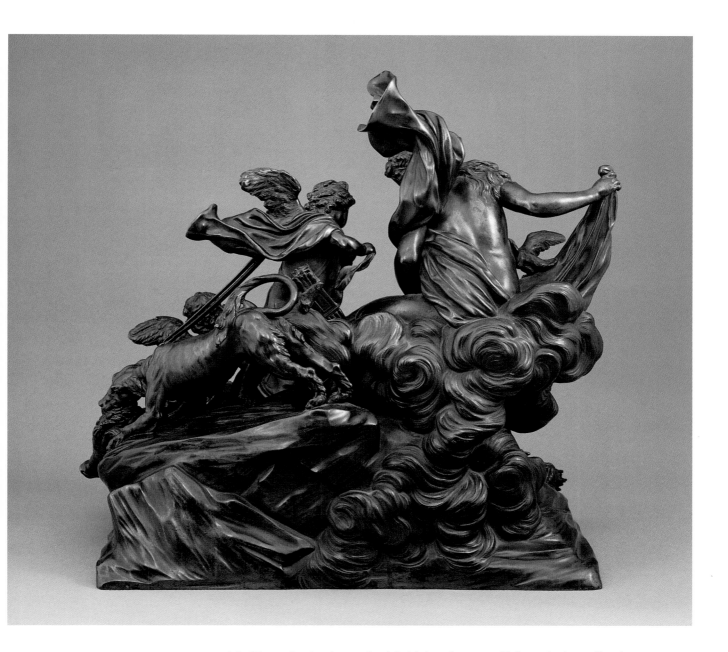

while Venus, having just arrived (with her drapery still fluttering), cradles the head of her paramour and looks into his eyes. Soldani uses the windblown drapery and other details to enhance the excitement of the drama and to demonstrate his superlative bronze-casting skills. For example, the dog's leash, which is being pulled by the standing cupid, is stretched tautly in a way that seems to defy the static quality of bronze.

A second bronze version of this group, in the Walters Art Gallery, Baltimore, retains its original base that includes a cartouche inscribed *AMORE RESVRGAM* (Love will resurrect). This refers to Ovid's description of the drops of blood from the wound in Adonis's thigh, which, as they touched the ground, were immediately transformed into anemones—a detail rendered in the Museum's work. PF

30 EDME BOUCHARDON
French (active in Rome and Paris), 1698–1762
Saint Bartholomew,
circa 1734–1750

Terracotta
57.2 cm (22½ in.)
94.SC.23

Bouchardon was one of the most significant sculptors in eighteenth-century France and his works provided a key stylistic link between the grand Baroque classicism of Louis XIV and the Neoclassicism that flourished from around 1750. One of the earliest French sculptors to explore a full-blown Neoclassical style, Bouchardon avoided dry academicism through the naturalistic modeling of surfaces, the elegant attenuation of figural proportions, and the introduction of simple, graceful poses. This terracotta *Saint Bartholomew* is probably a preliminary, rejected model for Bouchardon's decoration of the Church of Saint-Sulpice in Paris. The commission, which occupied the sculptor from 1734 until 1750, called for life-size stone statues in front of each pillar of the nave and choir. The narrow, contained compositions of the figures, as seen in the *Saint Bartholomew*, conform to the exigencies of this placement. Although the final statue of *Saint Bartholomew* does not resemble the Museum's model, two other Saint-Sulpice figures, *Saint Peter* and *Saint Andrew*, closely follow the terracotta in pose, drapery, and anatomy.

The subject of the terracotta, Saint Bartholomew, lived in the first century and is supposed to have preached in India and Armenia before being flayed alive and beheaded. The saint is commonly portrayed holding a knife, the instrument of his martyrdom, with his own flayed skin draped over one arm or laid on a tree stump. The saint was a popular subject in paintings from the sixteenth to eighteenth centuries, but he rarely appears in sculpture. In Bouchardon's portrayal, the seminude saint stands with his hands clenched around a book and gazes far off to his right as if absorbed in a divine vision. The old man's loose flesh and gaunt facial features are treated with exceptional sensitivity. The flayed skin, which hangs off the back of the tree stump, is rendered in gruesome detail, with the sagging hands, feet, and genitalia fully articulated. PAF

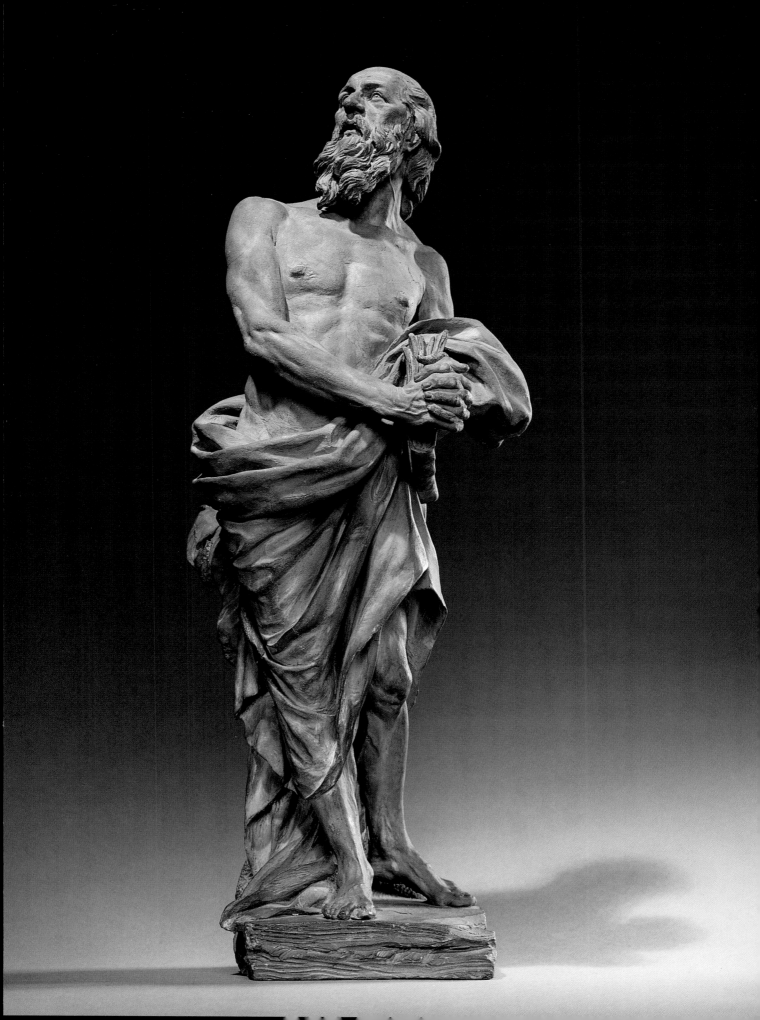

31 JACQUES-FRANÇOIS-JOSEPH SALY

French (born in Valenciennes; active in Rome, Paris, and Copenhagen), 1717–1776

Faun Holding a Goat, 1751

Marble
84.1 cm (33⅛ in.)
Inscribed, erroneously, on the base:
NL. COUSTOU FECIT 1715
85.SA.50

This marble depicts a lithe nude male posed in classical contrapposto, leaning on a tree stump and holding a small goat. The figure can be identified as a faun (a mythological creature of the woods) by means of the small tail above his buttocks, the inclusion of a goat to reflect his own goatlike features, and the display of musical instruments often associated with fauns and satyrs. The sculptor, Saly, spent the years 1740 to 1748 as a student at the Académie Française in Rome. His numerous studies and copies after the antique are evident in his composition for the *Faun Holding a Goat*, which is based on at least two famous ancient statues: the *Faun with a Kid*, now in the Museo Nacional del Prado in Madrid, and the *Satyr with Grapes and a Goat*, now in the Museo Capitolino in Rome.

Saly executed the terracotta model for this marble statuette when he was still in Rome. Shortly after his return to Paris, he submitted a plaster version to the Académie Royale de Peinture et de Sculpture as part of his application for membership. If the *morceau de réception*, or reception piece, was approved by the Académie, its execution in marble was commissioned. The resulting sculpture, if accepted, entitled the artist to full membership. Saly's *Faun Holding a Goat* was accepted, and he was unanimously voted a member of the Académie in 1751. Like other reception pieces—which were essential for the advancement of an artist's career—Saly's *Faun* is one of his most exquisitely carved and carefully finished works. With the exhibition of the marble in the Paris Salon of 1751, Saly achieved instant recognition and was thereafter patronized by Louis XV, Madame de Pompadour, and Christian VII of Denmark. PAF

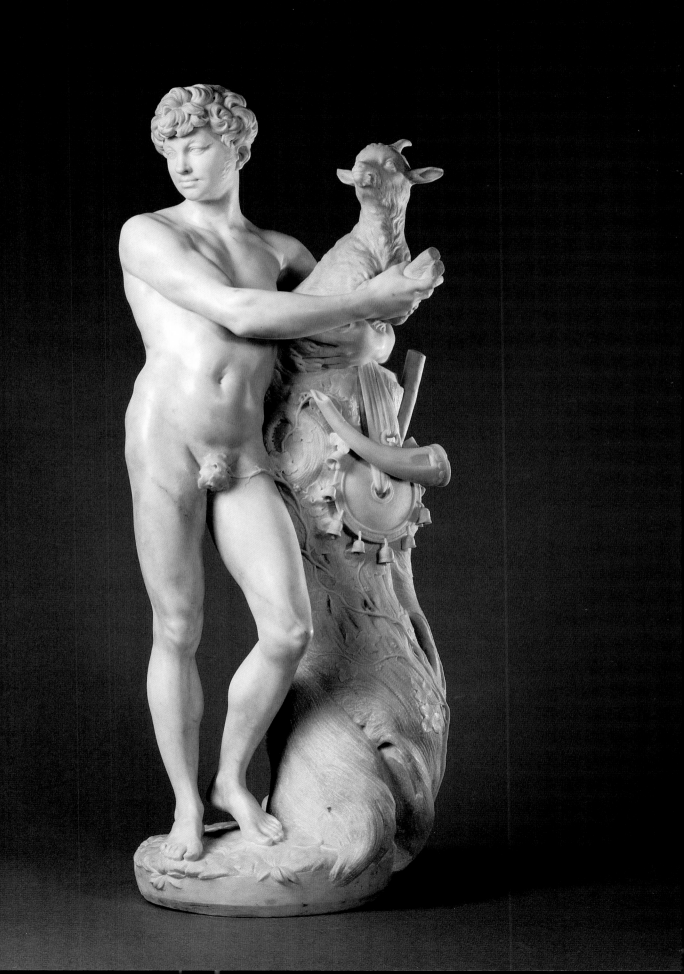

32 FRANCIS HARWOOD
English (active in Florence),
active 1748–1783
Bust of a Man, 1758

Black sandy limestone
(*pietra da paragone*) on a
yellow Siena marble socle
With socle: 69.9 cm (27½ in.)
Inscribed along the bottom of
the proper left side and back:
F. Harwood Fecit 1758
88.SA.114

One of the few English sculptors to settle permanently in Italy, Harwood devoted most of his career to supplying British aristocrats with copies and reductions of famous antiquities, as well as with marble urns and chimneypieces to decorate their country houses. The Museum's bust appears to be Harwood's only known portrait that is not directly based on an ancient or contemporary prototype. It is by far his most beautiful and original work. The sitter is depicted with a broad, smooth, muscular chest and shoulders that end in a sweeping arc. The nudity of the chest, the shape of the termination, and the placement of the bust on a rounded, classical socle recall ancient portrait busts and reflect Harwood's antiquarian interests. They also serve to ennoble the sitter by associating him with ancient precedents.

The identity of the sitter is unknown. His particularized facial features and the inclusion of a small scar at the top of his forehead above his right eye suggest that the sculpture portrays a specific individual. This, along with the bust's dignified expression and antique associations, makes the portrait exceptional not only within Harwood's oeuvre but also within the broader history of European representations of people of color. First brought to Britain in 1555, by the eighteenth century Africans were familiar figures in English society. However, their depiction in art remained largely stereotyped. In paintings they were usually portrayed as servants and relegated to the background. In sculpture, their features and costume were generalized to serve as symbols of exoticism. Harwood's bust, by contrast, is a rare, if not unique, eighteenth-century European portrait of a black individual.

PAF

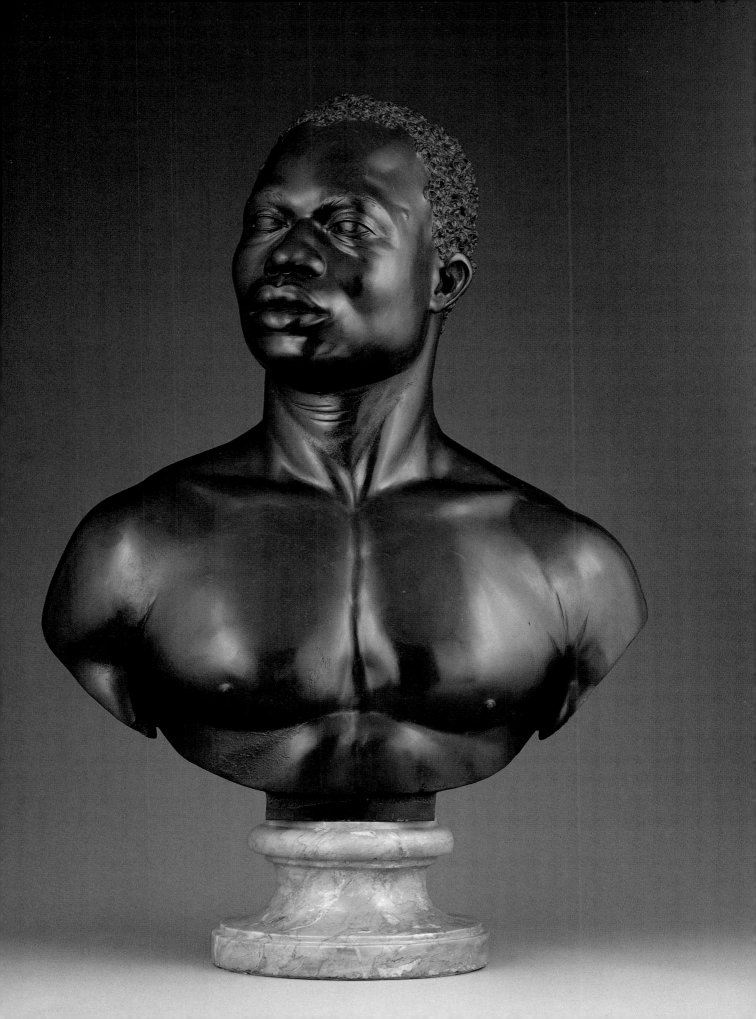

33 JEAN-JACQUES CAFFIERI
French (Paris), 1725–1792
*Bust of Alexis-Jean-Eustache
Taitbout*, 1762

Terracotta
With plaster socle: 64.5 cm (25⅜ in.)
Inscribed on the back: *M. Taitbout,
ecuyer, chevalier de St. Lazare consul
de France a Naples, Fait par j.j. Caffieri
en 1762*
96.SC.344

Last and most celebrated member of a renowned family of artists, Jean-Jacques Caffieri studied with his father, Jacques, and with Jean-Baptiste Lemoyne in Paris. He won the *prix de Rome* in 1748 and, while in Italy, worked under the painters Jean-François de Troy and Charles Natoire. In 1757, Caffieri exhibited religious and allegorical works as well as portrait busts at the Paris Salon, and, two years later, he became a member of the Académie Royale de Peinture et de Sculpture.

Caffieri's fame was first established by the series of portraits he executed for the Théâtre Français, and throughout his career he produced numerous busts of celebrated contemporaries. Reflecting the spirit of the Age of Enlightenment, Caffieri combined naturalism and realism with psychological acuity in the rendering of his subjects, and his *Bust of Alexis-Jean-Eustache Taitbout* is no exception. Caffieri has included such apparently unflattering details as Taitbout's prominent nose, furrowed forehead, bushy eyebrows, aging flesh, and blemishes, all of which contribute to the vitality of the image. The sitter, whose Belgian family moved to Paris under the reign of Henri IV, was a horseman, a knight of Saint-Lazare, and French general consul to Naples. Caffieri's portrait appears to be an incisive and sensitive rendering of a man whom the artist might have known personally from his trip to Naples in the 1750s. The informal nature of this bust suggests that the sculpture might have been commissioned either by the sitter himself or by someone close to him. The work's intimate character is underscored by showing Taitbout *en négligé*—in an unbuttoned shirt open at the neck—and by the freshness of its modeling, the sense of realistic detail, and its air of immediacy.

PAF and PF

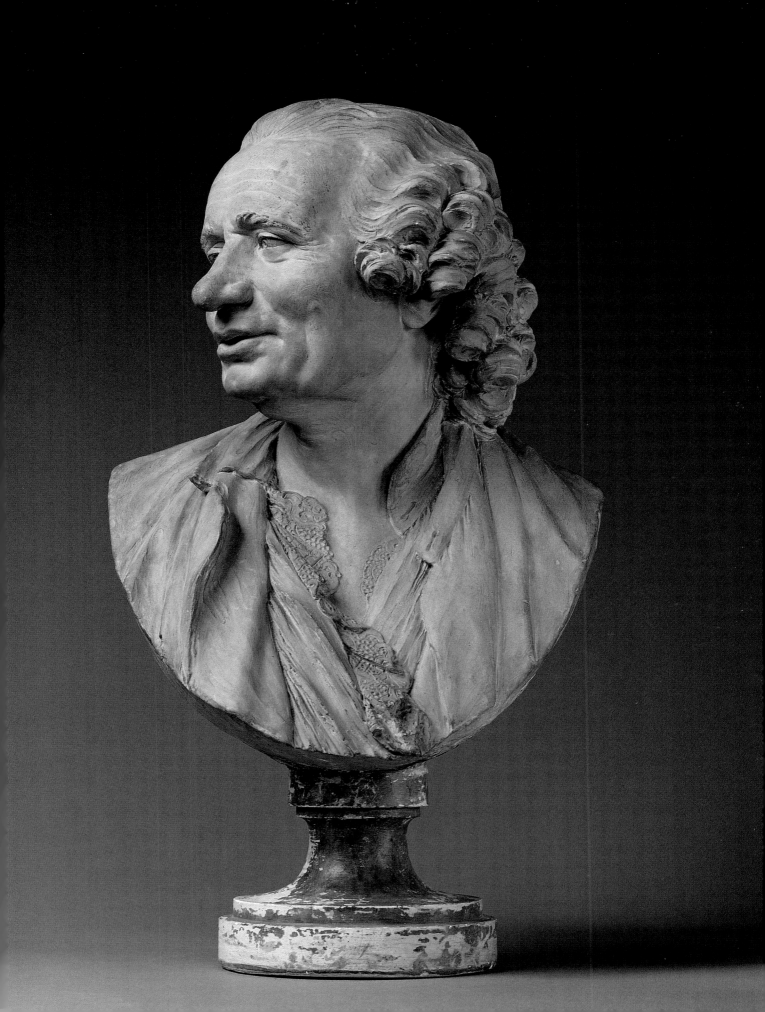

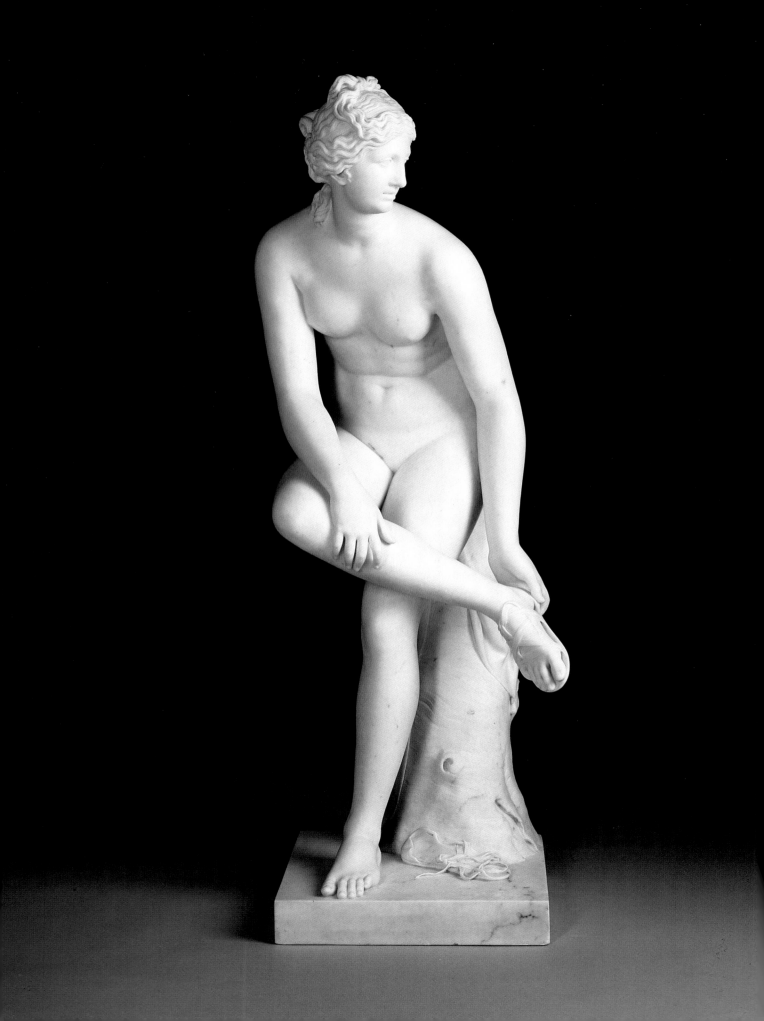

34 JOSEPH NOLLEKENS
English (London), 1737–1823
Venus, 1773

Marble
124 cm (48¹³/₁₆ in.)
Inscribed on the side of the base:
Nollekens F.ᵗ 1773
87.SA.106

Venus, one of three female deities by Nollekens in the Museum's collection, was commissioned by Charles Watson-Wentworth, the second marquess of Rockingham, to accompany a statue of *Paris* that Rockingham already owned and believed to be an important antiquity. With *Paris,* the marble goddesses—*Minerva, Juno,* and *Venus*—would have formed a group representing the classical myth in which the mortal shepherd was called upon to decide which goddess was the most beautiful. Nollekens chose to illustrate the beginning of the Judgment of Paris, depicting each divine contestant in a different stage of undress as she attempts to win the shepherd's vote. *Minerva,* the virgin goddess of wisdom and warfare and by far the most modest of the three, reaches up to remove her helmet. *Juno,* the goddess of marriage, bares one breast as she opens her dress. *Venus,* the goddess of love and the winner of the competition, is nude except for the single sandal she is removing.

Although known primarily as a sculptor of portrait busts and monuments, Nollekens had a particular interest in freestanding mythological figures. Because of the rarity of such commissions, the Museum's marble goddesses form one of the earliest important groups of gallery sculpture created by an English sculptor for an English patron. Nollekens studied in Rome for eight years, and his style, a mannered classicism inflected by coy charm, exhibits the influence of both ancient and sixteenth-century Italian sculpture. The statue of *Venus* draws upon a range of sculptural sources for its composition, including works by the Florentine Mannerist sculptor Giambologna. Nollekens's interest in Giambologna, as well as his inventive embellishments on basic mythological themes, underscores his lyrical and less rigid approach to the classical past.

PAF

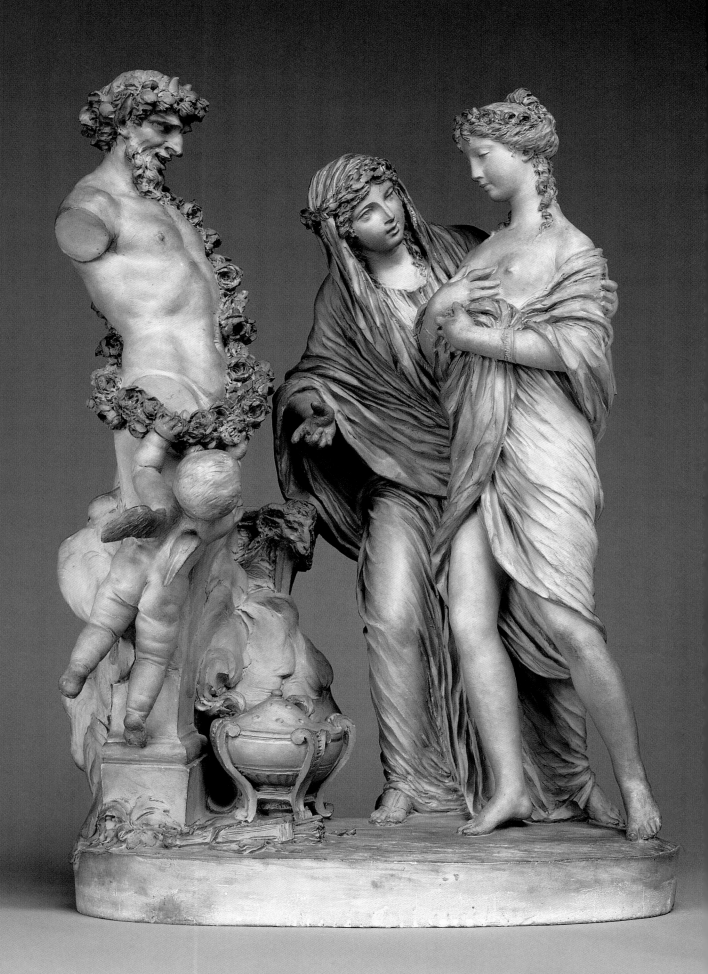

35 CLAUDE MICHEL,
called Clodion
French (born in Nancy;
also active in Rome and Paris),
1738–1814
*Vestal Presenting a Young
Woman at the Altar of Pan,*
circa 1775

Terracotta
45.1 cm (17¾ in.)
Inscribed on the clouds in
the back at right: *CLODION*
85.SC.166

Within the history of European sculpture, Clodion is perhaps the most famous modeler of clay. During his nine years of study in Rome (1762–1771), the renown of his terracottas became such that, as his earliest biographer records, these works were "bought by amateurs even before they were finished." Among his clients was Empress Catherine II of Russia, who attempted, without success, to attract Clodion to her court. While in Rome, Clodion capitalized on what had been a growing interest in terracottas as objects to be collected, and his technical brilliance also encouraged their aesthetic appreciation as independent works of art (rather than simply as sketches or models for works to be executed in more permanent media).

The Museum's work depicts a woman, dressed as a vestal, who leads a young girl before a term figure of Pan, the god of pastures and fertility. Cupid, whose bow and arrows lie on the ground, has just strategically hung a garland of roses around the term. The smoking incense burner and sacrificial tripod that stand beside Pan suggest that the term is an altar and that the scene is an initiation rite to love or marriage. Similar subjects—with figures in classicizing garb involved in scenes of love, sacrifice, and other ancient rites—became popular in France during the third quarter of the eighteenth century. They were treated by painters such as Charles Natoire, Joseph Vien, and Jean-Honoré Fragonard in the 1760s and 1770s, as well as by sculptors designing biscuit porcelain groups for the Sèvres manufactory. Reflecting a playful, romantic attitude toward the classical world, the *Vestal Presenting a Young Woman at the Altar of Pan* is typical of Clodion's work in its depiction of a non-serious genre scene with mythological figures of secondary rank. (Rarely did Clodion treat epic scenes or depict the major classical gods.) Also typical is the contrast of a grotesque male figure with a pretty female. This terracotta is meant to be read primarily from a frontal point of view, even though it is finished in the round. PF

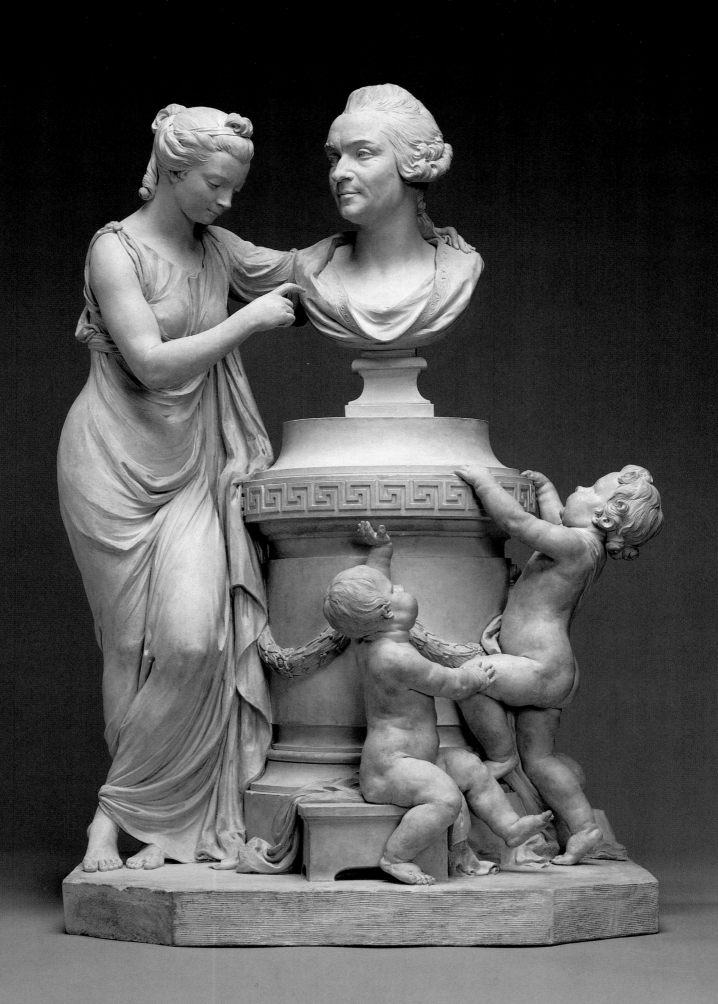

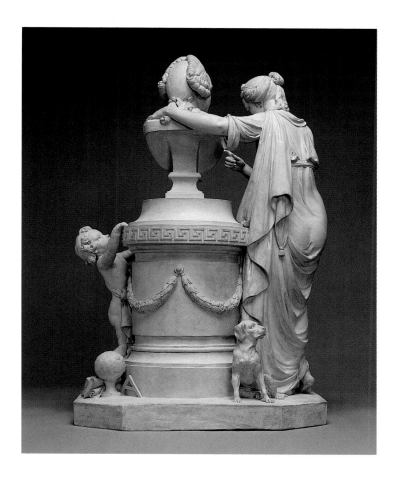

36 Attributed to
PHILIPPE-LAURENT
ROLAND
French (Paris), 1746–1816
Allegorical Group with a
Portrait Bust of an Architect
(possibly Pierre Rousseau),
circa 1780–1790

Terracotta
67.3 cm (26½ in.)
97.SC.9

This group centers around the bust of a man set on a classicizing, circular pedestal.
A female figure in antique costume and standing in the casual, cross-legged pose often
found in depictions of muses, wraps her left arm around the bust, which she points out
to two small children. One child sits upon a stool, looking up and gesturing toward the
portrait, while the other enthusiastically tries to climb the pedestal for a better view. On
the ground behind the standing child are the attributes of an architect—compass, square,
globe, books, and rolled sheets of paper—indicating the profession of the sitter. Finally,
a small dog, traditional symbol of marital fidelity and familial piety, sits behind the
female figure, suggesting another aspect of the life of the subject, his role as a family man.

This group integrates various elements typical of commemorative sculpture. The
combination of portrait bust and surrounding figures, for example, can be found in tomb
sculpture, although here the figures do not mourn but rather celebrate the sitter. In fact,
the placement of a portrait bust on a classicizing base is a convention of celebratory
images of famous men. The casual interaction of the figures with the portrait almost
suggests a familial relationship, while the didactic gesture of the woman recalls the
popular eighteenth-century moralizing subject of a mother instructing her children.

The attribution of the group to Roland is based on the soft, lyrical classicism
of the female figure, an aspect of his style developed during a five-year stay in Rome.
Furthermore, the sentimentality and the naturalism of the group—evident in the easy
pose of the woman and the careful rendering of her anatomy, in the playful energy of
the children, and in the softly modeled, sensitive quality of the bust—are characteristic
of documented sculptures by Roland.

MC

37 ANTONIO CANOVA
Italian (active in Rome),
1757–1822
Apollo Crowning Himself,
1781–1782

Marble
84.8 cm (33⅜ in.)
Inscribed on the tree trunk:
ANT.CANOVA/VENET.FACIEB./
1781
95.SA.71

Antonio Canova was considered the greatest Neoclassical sculptor from the 1790s until his death, and he was the most famous European artist of his time. Despite his reputation as a champion of Neoclassicism, Canova's earliest works, executed in Venice, exhibit greater stylistic affinity to late Baroque and Rococo sculpture. This statuette of *Apollo* was Canova's first Roman work in marble and marked a crucial turning point in his career. Inspired by his first-hand study of ancient statues, the figure served as an exemplar of the graceful style and idealized beauty that would become the sculptor's trademarks for the next forty years.

While in Rome in 1781, Canova was asked by Don Abbondio Rezzonico to produce this statuette of *Apollo* to be judged in competition with a figure of *Minerva* (now lost) by the Roman sculptor Giuseppe Angiolini. Canova's sculpture, intended to demonstrate his mastery of the Neoclassical style, is a study in classical pose and proportion. The nude god's stance conforms to a canonical contrapposto in which tensed limbs are opposite relaxed limbs and the body reposes in harmonious equilibrium. The subject of the statuette derives from a famous story in Ovid's *Metamorphoses*. Terrified by Apollo's lustful pursuit of her, the beautiful nymph Daphne prayed to the goddess Diana, who responded by transforming Daphne into a laurel tree to preserve her virginity. Apollo, crowning himself with laurel leaves, lamented, "Although you cannot be my bride, you shall at least be my tree. My hair, my lyre, my quiver shall always be entwined with you, O laurel" (1.557–559). Canova's choice of this relatively calm, rarely depicted, moment in an otherwise action-filled story reflects his desire to focus on a classically inspired nude—a task made easier by the lack of movement or extreme emotion. It also illustrates the sculptor's lifelong preference for poignant, introspective scenes. PAF

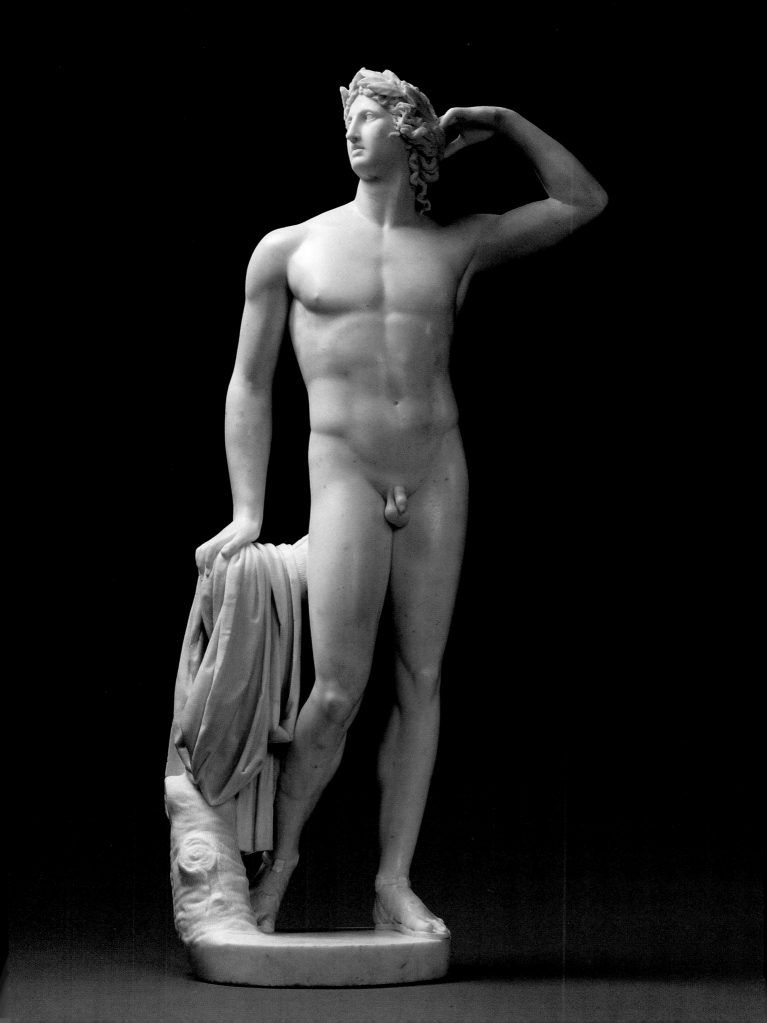

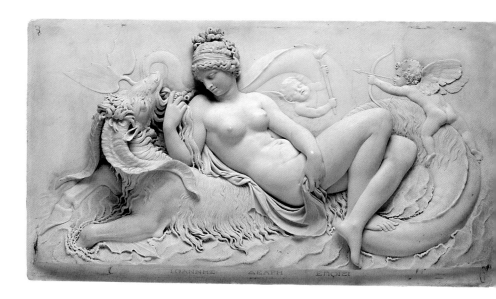

38 JOHN DEARE
British (born Liverpool, active in
London and Rome), 1759–1798
*Venus Reclining on a Sea
Monster with Cupid and a Putto*,
1785–1787

Marble
33.7 cm (13¼ in.)
Signed in Greek: ΙΩΑΝΝΗΣ
ΔΕΑΡΗ ΕΠΟΙΕΙ
98.SA.4

John Deare was one of the most accomplished and innovative British sculptors working in the Neoclassical style. He signed this relief ("John Deare made it") in Greek, rather than in the more usual Latin. A prodigy, he began an apprenticeship in 1776 with the sculptor Thomas Carter. In 1780, he became the youngest artist to win the Royal Academy's gold medal. Deare went to Rome in 1785 on an Academy stipend to study ancient sculpture. He produced independent works there and achieved great success, particularly among British tourists making the Grand Tour. His specialty was relief sculpture, and even Canova is said to have praised his work. Deare's flourishing career in Rome was cut short by his early death, reportedly from a fever brought on by his purposefully falling asleep on a cold block of marble, seeking inspiration for his next work from his dreams.

This relief shows Venus, goddess of love and beauty, reclining on a sea monster in the form of a goat with a fish tail. Venus entwines her fingers in the beard of the goat—a variation on the chin-chucking gesture that traditionally represents erotic intent—and the beast licks her hand in response. Cupid, astride the monster, is about to shoot an arrow at Venus, and a putto holds a flaming torch at the center of the scene, adding to the amorous imagery. That the relief represents an allegory of Lust is suggested by the placement of Venus on the sea goat—from medieval times, Lust was represented by a woman riding a goat.

The sea goat carries Venus through the frothy waves, carved with the energy and precision characteristic of Deare's virtuoso relief technique. Deare's reliefs typically present a great variety in levels of carving, displayed here, for example, by the fully three-dimensional snout of the sea goat, the body of Venus in half-relief, and the low relief of the Cupid and putto. In contrast to the cool, polished finish commonly found on Neoclassical marble sculpture, Deare's works present a heightened sensuality, with traces of tool and drill marks conveying a sense of the physical labor involved in marble carving. The refined *maniera* grace of the figure of Venus was inspired as much by sixteenth-century Florentine sculpture as it was by antiquity.

MC and PF

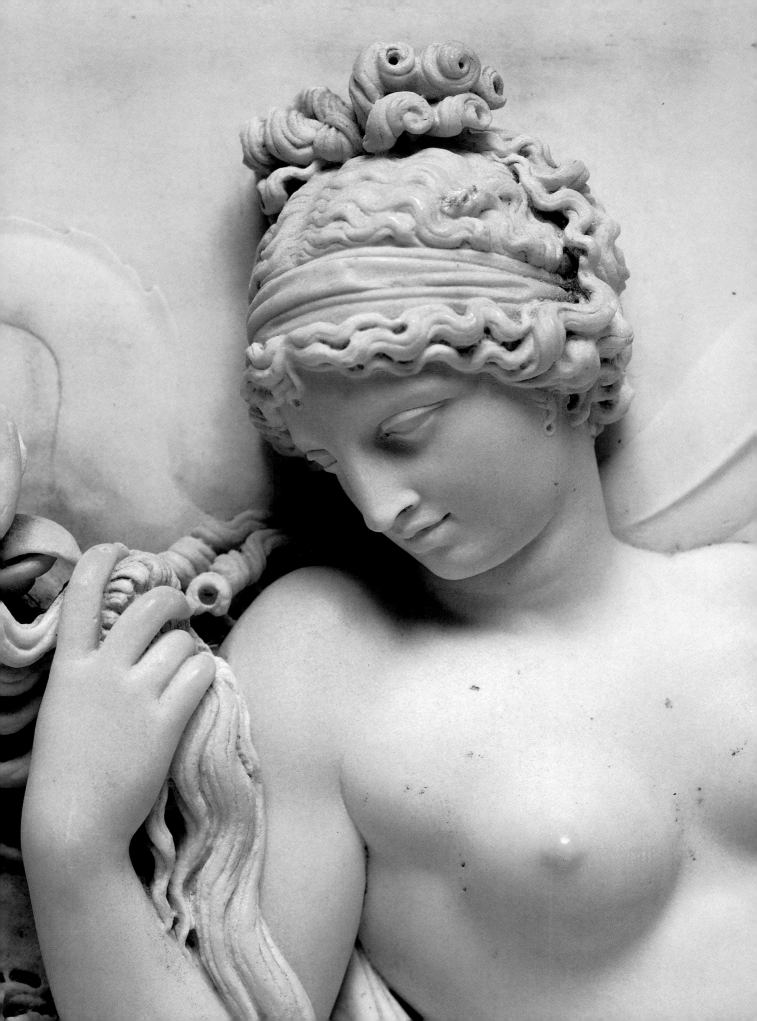

39 JOSEPH CHINARD
French (Lyons), 1756–1813
The Family of General Philippe-Guillaume Duhesme, circa 1808

Terracotta
56 cm (22¹⁄₁₆ in.)
Inscribed on the front:
chinard statuaire a Lyon
85.SC.82

Chinard was the leading French Empire sculptor and, after Canova, the favored sculptor of Napoleon and the Bonaparte family. Like the painter Jean-Auguste-Dominique Ingres, Chinard executed many large historical and mythological works, but he was especially prized as a brilliant portraitist. Particularly innovative in dealing with the formal problems of truncation in busts, Chinard mitigated the effect of the cuts and unified the bust with its socle or pedestal through his clever use of contemporary high-fashion accessories. By the inclusion of low-relief scenes and meaning-laden accessories, he introduced into portrait sculpture narrative elements that had traditionally been reserved almost exclusively for painted portraits.

It was probably Chinard more than anyone who established the lasting currency of the portrait medallion in nineteenth-century France. His small circular relief profiles of distinguished sitters—like the one held by the woman in the Museum's work—were produced in large editions, in plaster or biscuit, and became the prototype for thousands of similar objects executed during the rest of the century.

The Museum's work is characteristic of Chinard's sculpture in its use of classical composition and forms that provide the framework or support for detailed rendering of contemporary fashion. It depicts a family group, with the medallic portrait of General Duhesme being held and looked at by his wife and son. The figures are shown bound together by love in the form of the cupids who hold the rope encircling the daybed upon which mother and son are seated. This is a rare type of sculpture, combining as it does detailed portraits of three family members (in accurately depicted contemporary clothes and hair styles) into an imaginary and touching genre-like scene. It is a work that well represents Chinard's contributions to the history of sculpture—the infusion of storytelling elements into portraiture and the conflation of fact and fashion into purely aesthetic configurations.

Philippe-Guillaume Duhesme was born in Bourgneuf (Saône-et-Loire) in 1766 and died at Gennapes, Belgium, in 1815. In 1808 he was made Governor of Catalonia, Spain. Since Chinard died in 1813, two years prior to the death of General Duhesme, the present work cannot be a model for Duhesme's tomb. It seems most likely that the terracotta was executed in or shortly after 1808, when Duhesme went to Spain, leaving his family behind in France. Thus, the group probably served as a family keepsake portrait.

PF

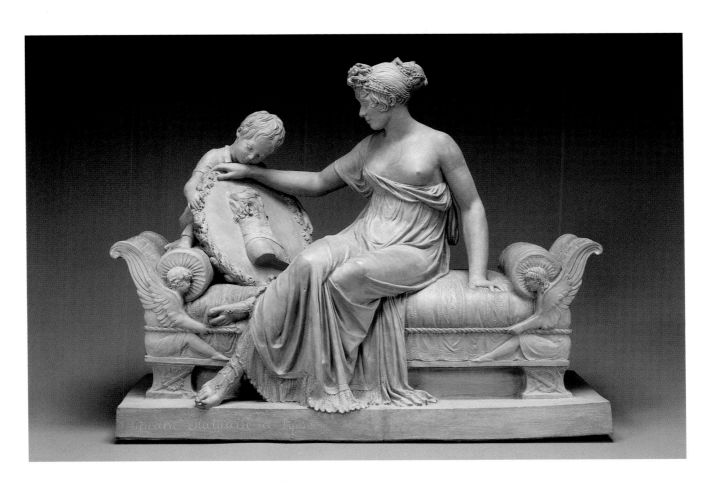

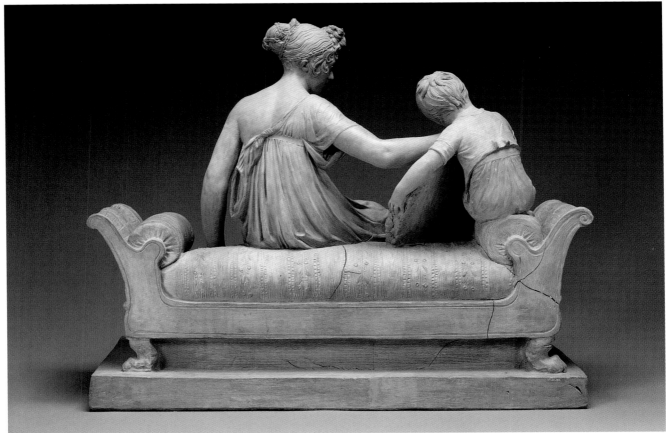

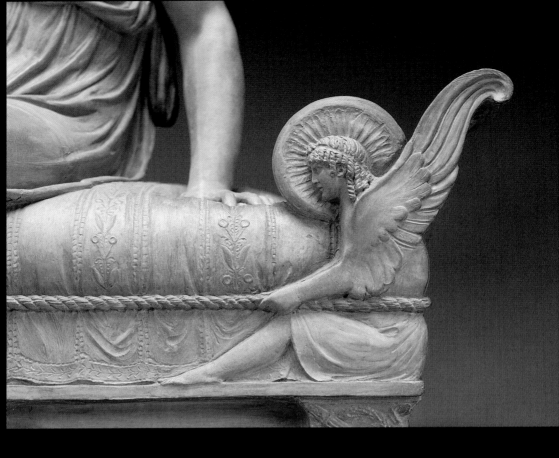

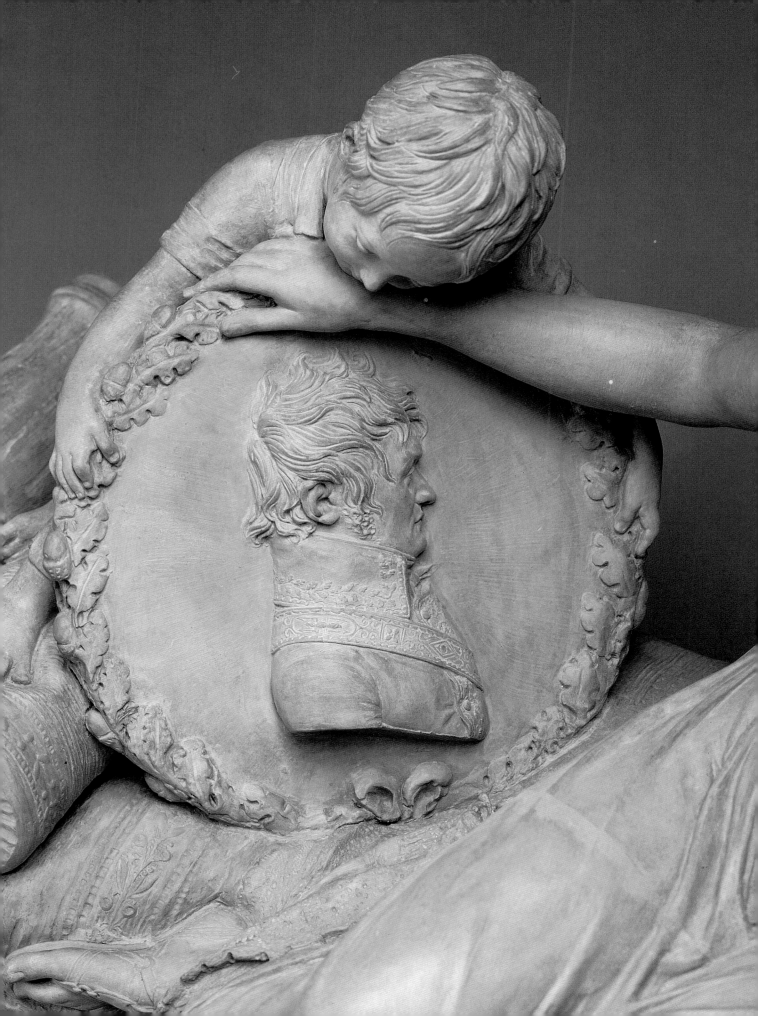

**40 PIERRE-JEAN DAVID
D'ANGERS**
French (active in Angers
and Paris), 1788–1856
Bust of Mary Robinson, 1824

Marble
46.4 cm (18¼ in.)
Inscribed on the side of the base:
P.J. DAVID/1824
93.SA.56

David d'Angers was the most innovative and influential portrait sculptor of the Romantic period. His early works, such as this bust of a young American woman, also reflect the influence of then-current Neoclassical trends. Mary Robinson is depicted with stark simplicity and an emphasis on geometric abstraction. Her features—judging from the bump below the bridge of her nose and her bow-shaped lips—are accurately rendered, but her nude chest terminates in an abstract, square herm. Her hair is swept up into two large loops that end in a loose array of curls. This elaborate coiffure plays upon the stylized, troubadour-like qualities of contemporary hair fashions and punctuates the bust with deeply carved, almost architectonic volumes. The geometric purity of the portrait is further emphasized by the complete lack of personal adornment in the form of costume, jewelry, or hair accessories. This combination of realistic facial features and abstract elements is characteristic of David d'Angers's female portraits of the 1820s and 1830s. Like the paintings of Jean-Auguste-Dominique Ingres, the *Bust of Mary Robinson* is an exquisite example of the stylized refinement common to the work of many artists of the early nineteenth century.

Mary Robinson was the daughter of Captain Henry Robinson (1782–1866) of Newburgh, New York. Captain Robinson was the sole or part owner of a number of packet boats that sailed the New York-to-Le Havre route. Perhaps through his recurrent travels to France, Robinson became a close friend of the marquis de Lafayette. It may have been Lafayette who introduced Robinson to David d'Angers and facilitated the commission for Mary's portrait. In 1831 David d'Angers also executed a portrait of Henry Robinson's wife, Ann Buchan Robinson (1791–1853); that marble bust is now in the Museum of the City of New York.

PAF